IMAGES
of America

MARYLAND
THOROUGHBRED RACING

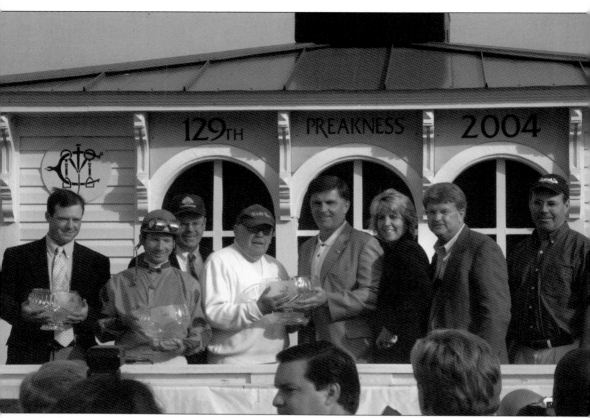

Country Life Farm's Merryland Missy wins the 2004 Maryland Million Distaff. Pictured from left to right are Jeff Brutscher, Stewart Elliot, Mike Pons, Joe Pons, Gov. Bob Ehrlich, Kendall Ehrlich, Jim Dresher, and Josh Pons. (Courtesy Ellen B. Pons.)

IMAGES
of America

MARYLAND
THOROUGHBRED RACING

Brooke Gunning
and Paige Horine

Published by Arcadia Publishing
Charleston SC, Chicago IL, Portsmouth NH, San Francisco CA

Printed in Great Britain

Library of Congress Catalog Card Number: 2005924867

For all general information contact Arcadia Publishing at:
Telephone 843-853-2070
Fax 843-853-0044
E-mail sales@arcadiapublishing.com
For customer service and orders:
Toll-Free 1-888-313-2665

Visit us on the internet at http://www.arcadiapublishing.com

To my friend who shares a love of racing. —Brooke
To Dadboy. —Paige

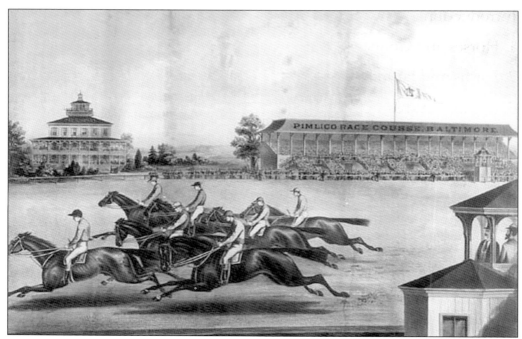

This is a famous lithograph of racing at Pimlico in the late 19th century. (Courtesy Cator Collection, Enoch Pratt Free Library.)

CONTENTS

Acknowledgments

Our deep gratitude goes to our families and to the following individuals and organizations, among others, for their invaluable time, assistance, and support: Lou Raffetto; Gov. Bob Ehrlich; Henry Fawell; John Reith; Jim McKay; Jeff Korman and Enoch Pratt Free Library; Phyllis Rogers and Keeneland Library; Cricket Goodall; Barrie Reightler; Cindy Deubler and the rest of the staff at the Maryland Horse Breeders Association (MHBA); Libby Anderson; Bill Beehler; Molly O'Donovan; Betty Shea Miller; Ellen and Josh Pons and the rest of the folks at Country Life Farm; Richie Blue; Bill and Ginny Boniface; Michael and Laura Finney; Tom Hearn; Maria and Guido Bortot; Laura Powell; Jeff Price; Peggy Watson Strott; Lee Watson; Parker Watson; Kelly Young; Ned Rosenberg; Nicole du Pont; Don Litz, Wayne Morris, and the others at the Maryland Stallion Station; the Maryland State Fair, especially Edie Bernier; Andy Cashman and Max Mosner; the Cecil County Historical Society, especially Mike Dixon; the Harford County Historical Society, especially Maryann Skowronski; and everyone at the Oregon Grill. Special thanks to Winslow, Rene, John, Devon, and Amelia for their support.

To the best of our ability, we have attempted to ensure accuracy, given the often antiquated or obscure nature of the subject matter and materials.

References

Anderson, C. W. *A Touch of Greatness*. New York: The Macmillan Company, 1945.

———. *Black, Bay and Chestnut—Profiles of Twenty Favorite Horses*. New York: The Macmillan Company, 1939.

———. *Deep Through the Heart—Profiles of Twenty Valiant Horses*. New York: The Macmillan Company, 1940.

———. *The Smashers*. New York: Harper & Brothers Publishers, 1952.

Finney, Humphrey S. *A Stud Farm Diary*. London: J. A. Allen, 1935.

———. *Fair Exchange: Recollections of a Life with Horses*. New York: Charles Scribners, 1978.

Lennox, Muriel. *Dark Horse*. Ontario: Beach House Books, 1985.

Livingston, Bernhard. *Their Turf—America's Horsey Set and its Princely Dynasties*. New York: Arbor House, 1973.

Pons, Josh. *Country Life Diary—3 Years in the Life of a Horse Farm*. Lexington, KY: The Blood-Horse Inc., 1992.

Sciliano, Sam, ed. *The Preakness: Middle Jewel of the Triple Crown*. Maryland Jockey Club: 1978.

(Numerous issues of *The Maryland Horse* and *Mid-Atlantic Thoroughbred* have provided insights and helpful material.)

INTRODUCTION

Jousting (yes, you read that correctly) may be the official state sport of Maryland, but as any Marylander worth his trifecta ticket will tell you (with courtly eloquence), it is Thoroughbred flat racing that truly holds his heart (and, in some cases, his wallet). The history of Thoroughbred racing in Maryland stretches from its early Colonial days through the present, with a hopeful eye toward the future.

This book will highlight subjects ranging from the legendary to the forgotten, from millionaires to railbirds. Horse racing is a great equalizer, drawing fans from all ages and walks of life. It is part of the bond that has held Marylanders together for centuries and played a proud and important role in the state's identity and economy.

Ever since Maryland's inception as a colony of the British Empire, it has been impossible to separate the people from their horses. Their role was not strictly limited to use as a mode of transport or for practical purposes such as pulling plows, wagons, fire engines, or gun carriages. They were also used for sport. In fact, horse racing may well have been America's first spectator sport.

In 1742, provincial governor Samuel Ogle headed off to England with his new bride for a honeymoon that lasted almost half a decade. Upon their return, they brought with them a fine gift from Lord Baltimore—two Thoroughbreds whose lineage was traced back to the Royal Stud. They settled in at their elegant residence, Belair, which over the next few centuries would become the renowned home to some of the racing world's most legendary horses. Later owned by the Woodward family, it was called home by Gallant Fox, Omaha, Flares, Johnstown, Nashua, and Segula. This farm, and others like it, formed the cornerstone of Maryland's honorable tradition.

The venerable Maryland Jockey Club, founded in 1743, is the oldest racing association in our country. Founded in Annapolis, the state's capitol, meetings have been held in varying locations for most of the many years since its inception, with time out for unavoidable historical intrusions, such as the Revolutionary War, the French-Indian War, and the Civil War. George Washington was fond of attending, and many politicians and luminaries found their way to Baltimore's racetracks to watch the best racing our country had to offer. The smaller tracks, most of which are no more than fond memories, have given way to parking lots, car dealerships, and housing developments. The big tracks at Pimlico and Laurel now fight to hold their own.

Challedon, Native Dancer, Paul Jones, Ruffian, Man o'War, War Admiral, and Seabiscuit—and those now obscure—thunder down the pages of Maryland's history. The farms, great and small, frequently family-operated for generations, and all the nameless faces who fed and watered, exercised and loved these animals—people who dedicated their lives to the sport—call out to the present. They call to us to not let our shared dream vanish.

It is the beauty of the sport that makes one cry, without knowing why; the grace, the sheer synchronicity between horse and rider, the fleetingness of the moment. There is a flash of greatness, a blur of beauty—a winner perhaps, perhaps not—the marvelous but fleeting feeling that the horse is yours, that the win could be yours, if not now, then on to the next hope, the next dream, the next great race.

One

HORSES AND COURSES

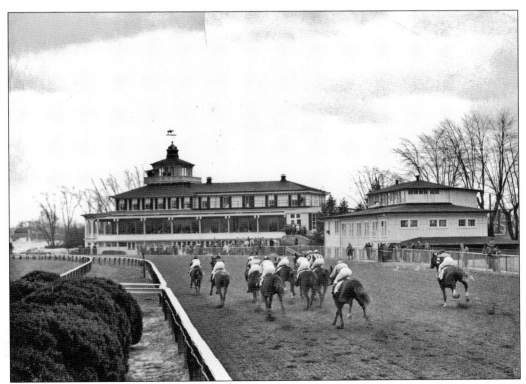

Horses race toward the old clubhouse at Pimlico on an overcast day. Note the famous weather vane atop the cupola of the old clubhouse. Each year the Preakness winner's silks are painted on the jockey, a position of honor that will remain until the end of the next Preakness. (Courtesy Enoch Pratt Free Library.)

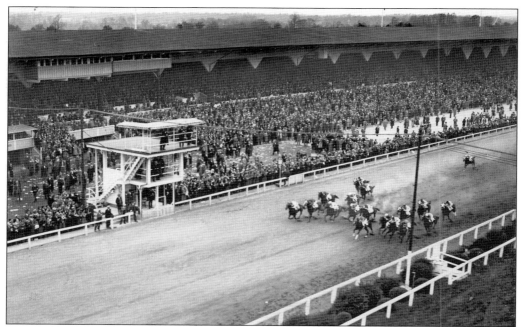

Racing has held the interest of Marylanders for generations. Here a packed grandstand at Pimlico cheers for its favorites. (Courtesy Maryland Jockey Club.)

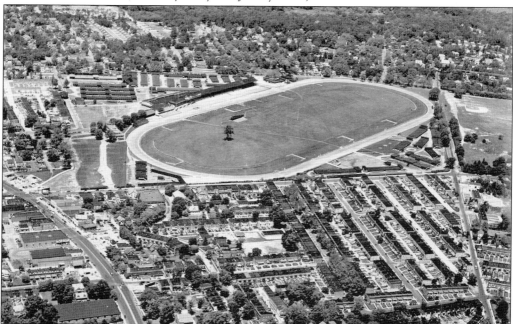

This aerial view of Pimlico shows how the city has encroached upon it. To the left of the track are the grandstands and stables, as well as a blacksmith shop, kitchen, and sundry dependency buildings. Pimlico has survived several wars, fire, the Great Depression, and lesser depressions. Whether it will be able to withstand the battle over slots remains to be seen. (Courtesy Enoch Pratt Free Library.)

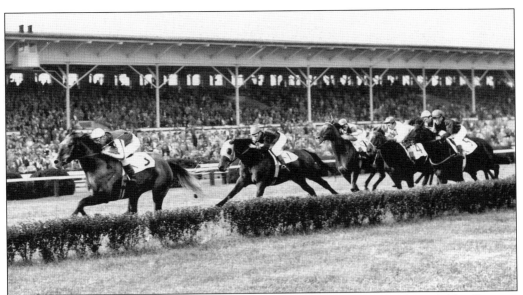

Everyone has his or her own system for selecting a winner. Whether it be through bloodlines or past finishes, or just because one likes the name, none of these systems deserves ridicule. One old adage instructs to "always bet the gray." Try it sometime and let us know how you fare. (Courtesy Enoch Pratt Free Library.)

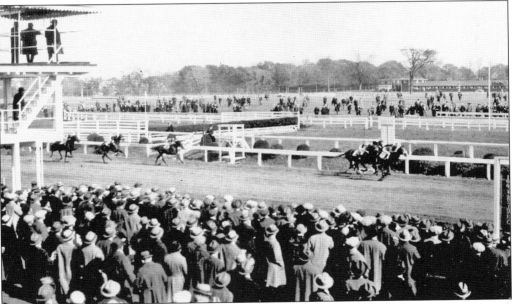

Here is a view toward the finish line during the 1930 season, complete with a cheering crowd. As with any group of fans (short for fanatic) or participants, there's always someone who takes things a step further than the rest. Such was the case with jockey Willie Doyle, who rode to victory in the 1909 Preakness. Upon his death, his last wish was granted and his ashes were sprinkled by the finish line. Years later, the finish line was moved, and a thoughtful soul took a spadeful of soil (figuratively his ashes) and moved it to the new finish line. (Courtesy Enoch Pratt Free Library.)

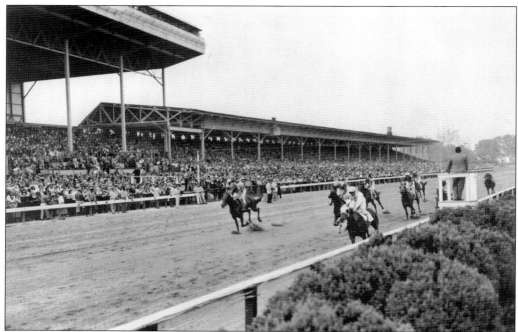

Going to the races was a relatively inexpensive way to spend a day off. In the days before 24-hour television with 500 channels to choose from, one had to travel to view sporting events. Most of the racetracks were accessible by horse, then later on by car or train. (Courtesy Enoch Pratt Free Library.)

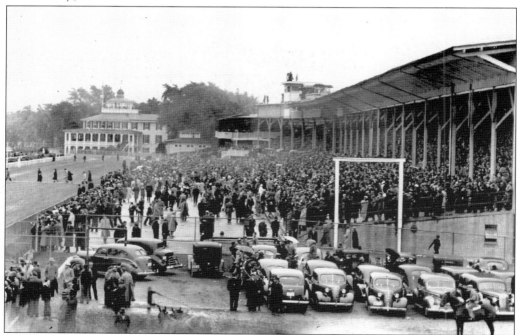

The Pimlico parking lot is more packed with Packards than usual on this Preakness day in the 1940s. (Courtesy Enoch Pratt Free Library.)

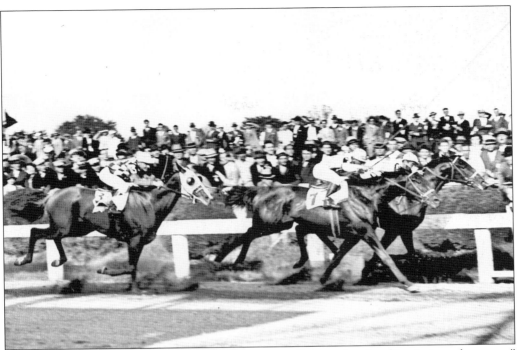

Horse races are often quite close, hence the expressions "winner by a head" or "winner by a nose." Note how close the fans are to the rail. (Courtesy Enoch Pratt Free Library.)

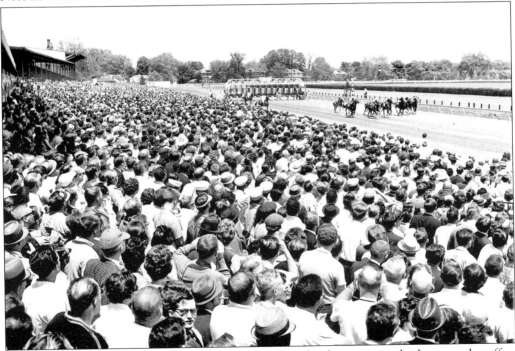

As this large crowd demonstrates, the races were a popular destination, whether on a day off or when playing hooky. (Courtesy Enoch Pratt Free Library.)

Nineteenth Annual Yearling Show

For Thoroughbred Yearlings
Foaled In Maryland In 1952

Pimlico Race Course
(Courtesy of Maryland Jockey Club)

TUESDAY, MAY 19, 1953, 10 A.M.

PRESTON M. BURCH, Judge

Maryland Horse Breeders' Ass'n.
614 YORK ROAD, TOWSON 4

Shown here is a brochure for the annual Pimlico Yearling Sale. Interested parties would have the opportunity to perhaps find a future Preakness winner. (Courtesy Enoch Pratt Free Library.)

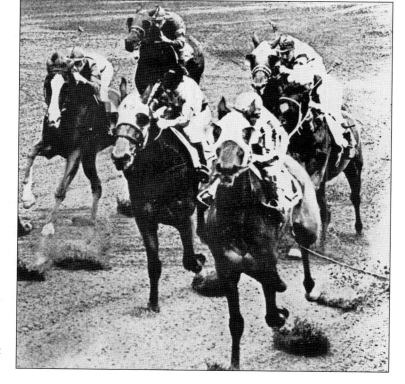

A jockey's life is not for the fainthearted, as racing is an inherently dangerous sport. Jockeys must also know their mounts' strengths and weaknesses, as well as their competitors', to best strategize a trip to the winner's circle. (Courtesy Enoch Pratt Free Library.)

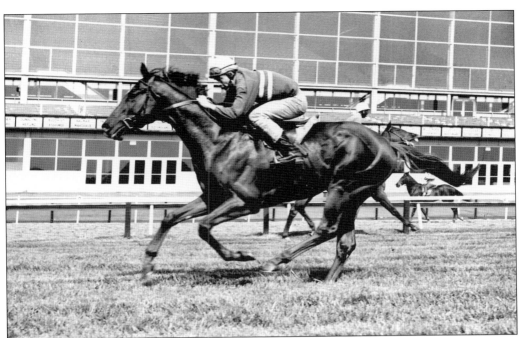

Just like a human athlete, racehorses need to be conditioned and kept in shape. A good time for workouts is the early morning. In this photograph, note the type of tack and equipment, as well as the jockey's position; they are quite different than that of a pleasure rider or cowboy. (Courtesy Enoch Pratt Free Library.)

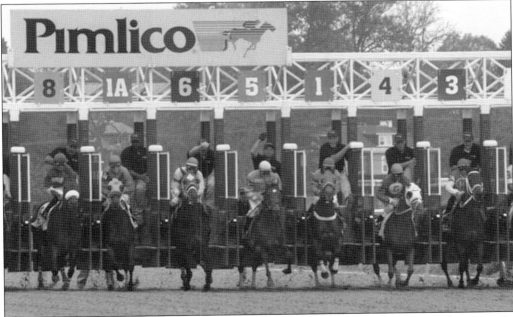

Track conditions can affect both the timing and the winner of a race, just as surely as certain horses have different aptitudes at different lengths. For example, horses that do well on a sloppy track are called "mudders." (Courtesy Enoch Pratt Free Library.)

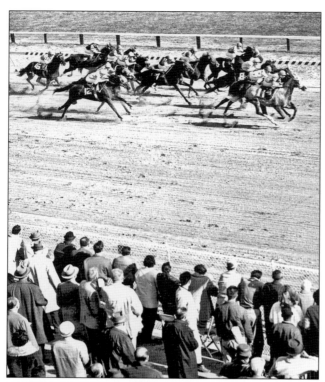

The excitement of watching the horses thunder by while rooting for your horse to win is a thrill unmatched in the mundane aspects of life. It is a small wonder that many become ardent fans. (Courtesy Enoch Pratt Free Library.)

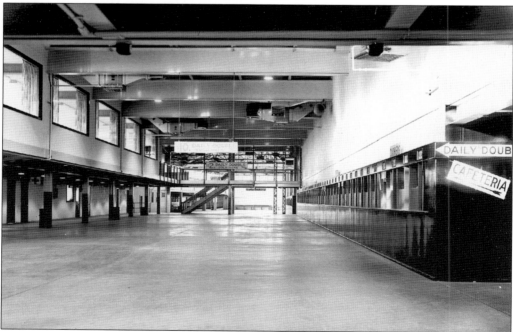

You can bet that the only reason there are no lines at these betting windows is that the track is closed. Soon enough, there will be lines of the hopeful. Note the $10 Daily Double sign. (Courtesy Enoch Pratt Free Library.)

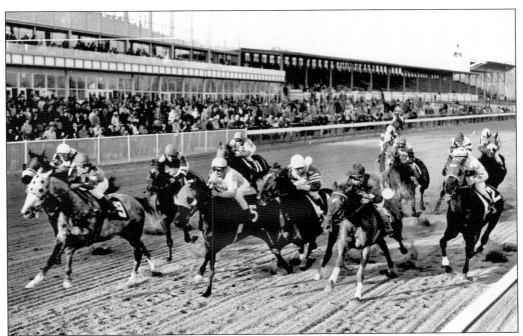

There is often a lot that transpires during a race that the average spectator can't see. A jockey needs to keep focused if he wants to win. Here, two jockeys appear to be in a bit of a dispute, as others look on. (Courtesy Enoch Pratt Free Library.)

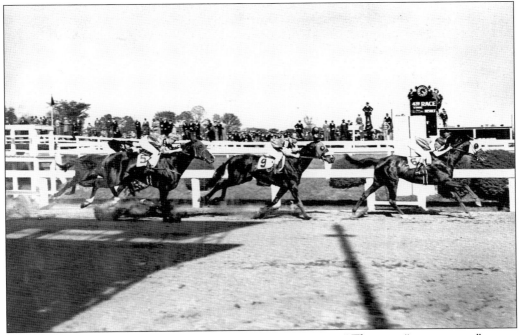

Number 6 has just won the fourth race and will receive a "purse." The term "purse money" comes from long-gone days when the winning jockey literally would claim a purse of coins that hung by the finish line. (Courtesy Enoch Pratt Free Library.)

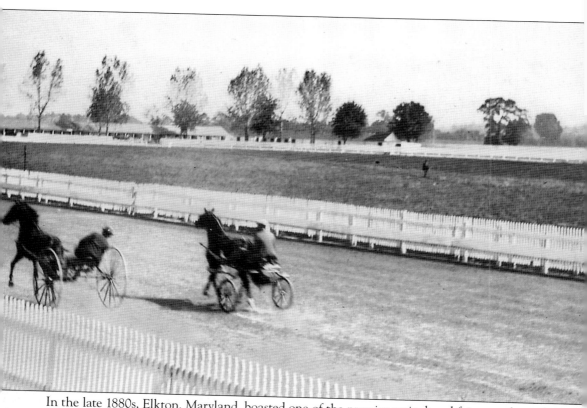

In the late 1880s, Elkton, Maryland, boasted one of the premier agricultural fairgrounds on the East Coast. The grounds were constructed in 1880 by the Cecil County Agricultural Society. The fairgrounds were to be built on a parcel of land next to the railroad depot owned by A. G. Tuite. Various committees organized the building of stables, fencing, grandstands, ticket offices, and judges' stands. The grandstand was to be a copy of the grandstands at Pimlico, 150 feet by 40 feet in size. The *Whig*, the Cecil County newspaper that is still in operation today, reports: "The basement floor will be used as a hall for general exhibitions of household products etc. The track for trails [*sic*] of speed, which is to be seventy feet wide, has already been laid out by E. Larkins Esq. Engineer of the P.W. & B Railroad Company and graded to stakes." (Courtesy the Cecil County Historical Society.)

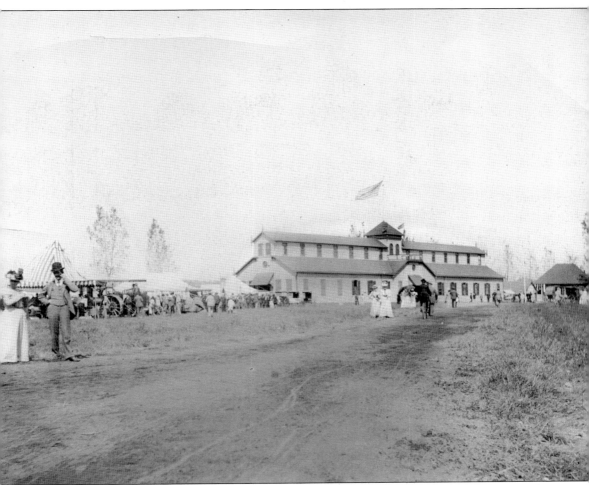

The building on the left is Mitchell Hall, built in 1894 by Levi O'Cameron. It was the site of the Farmer's Sociable. Lights on loan from the PW&B Railroad provided the illumination while couples danced to Prof. John B. Ritchie's Orchestra from Wilmington. By 1894, the Elkton Fair was at its peak. Sixteen thousand people attended that year, with 2,500 people arriving by train. This success was not for long, as the fair ceased to exist after the turn of the century. (Courtesy the Cecil County Historical Society.)

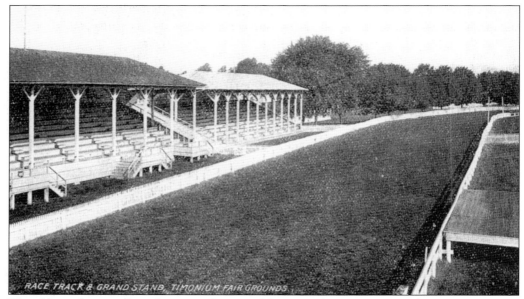

RACE TRACK & GRAND STAND, TIMONIUM FAIR GROUNDS

The old wooden grandstands are a reflection of days gone by. At one time, there were two state fairs. One was held at Pimlico and operated by the Maryland Jockey Club, and the other was held at Timonium. They held joint fairs in 1894 and 1897, but by the turn of the century, the Maryland Jockey Club had gained control of the Timonium Fair and both groups incorporated as the Maryland State Fair and Agricultural Society. In 1937, Timonium became the official site of the Maryland State Fair. (Courtesy Andy Cashman.)

From 1956 to 1958, the Timonium Race Track underwent extensive renovations. The parking lot was expanded, and a new grandstand was built as well as facilities for jockeys and racing officials. In 1963, Max Mosner, who is now the general manager of the Maryland State Fair, joined the fair staff. A great change came about in 1970, when the Maryland Racing Commission shifted most Timonium racing dates to longer tracks, giving the Maryland State Fair a $500,000 yearly grant to offset the loss of revenue. (Courtesy of Edie Bernier.)

In 1943–1946, Timonium Race Track was pressed into military action when it was occupied by the army as a storage depot and vehicle repair facility. In 1950, the Maryland Jockey Club supported selling the fairgrounds to a local business, Black & Decker. A group of locals raised $600,000 to buy the fair and set up a nonprofit organization to run it. (Courtesy Andy Cashman.)

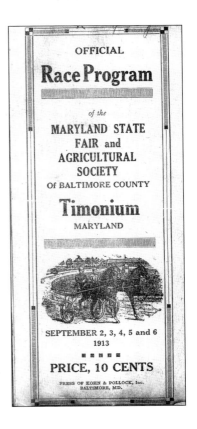

Local sponsors often supported the local racetrack. The town of Timonium actually began as a 320-acre property named Bellefield. In 1780, the owner renamed her property, located on Timonium Road near York Road, "Timonium." In the early 19th century, a mile-long race course was built by area residents just west of the present track. (Courtesy Andy Cashman.)

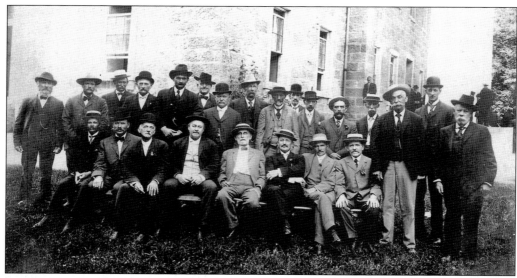

In 1878, Maryland businessmen gathered to create an organization called the Agricultural Society of Baltimore County and Maryland State Fair. These founding fathers, shown here in front of the Baltimore County Court House located in Towson, Maryland, are the founders of what is now the Maryland State Fair. (Courtesy the Maryland State Fair.)

MARYLAND RACING DATES

For 1936

Bowie, Apr. 1-11	Marlboro, Sept. 1-5
H.de Grace, Apr. 13-28	Timonium, Sep. 7-12†
Pim., Apr. 29, May 16	H. de Grace, Sep. 18-30
Hag'st'n, May 19-23*	Laurel, Oct. 3-31
Hag'st'n, May 26-30*	Pimlico, Nov. 2 11
Cumberl'd, Aug. 18-22	Bowie, Nov. 12-28
Cumberl'd, Aug. 25-29	

*Not yet approved by commission.
†No racing on September 8.

OTHER TRACKS

New Orleans, Nov. 28-Mar. 29	Aqueduct, L. I., June 8-July 2
Hialeah Pk., Miami, Jan. 16-Mar. 9	Suffolk Downs, Mass., June 13-Aug. 15
Houston, Tex., Feb. 29-Mar. 24	Hamilton, Ont., June 25-July 26
Tropical Pk., Miami, Mar. 10-Apr. 4	Empire City, N. Y., July 3-28
Jamaica, L. I., Apr. 15-May 9	Fort·Erie, Ont., July 4-11
Churchhill Downs, Apr. 25-May 16	Saratoga Spgs., N.Y., July 29-Aug. 29
Narragansett, R. I., May 2-23	Narragansett, R. I., Aug. 17-Sept. 26
Belmont Pk., L. I., May 11-June 6	Aqueduct, L. I., Aug. 31-Sept. 16
Charles Town, W.Va., May 14-July 7 (Dates tentative)	Belmont Pk.. L. I., Sept. 17-Oct. 3
Latonia, Ky., May 23-June 20	Jamaica, L. I., Oct. 5-17
Rockingham, N. H., May 25-June 12	Empire City, N. Y., Oct. 19-31
	Narragansett, R. I., Oct. 19-Nov. 11

Gaby and Greg Johnson, Foremost Handicapers,

Write for

THE BALTIMORE NEWS-POST

BALTIMORE SUNDAY AMERICAN

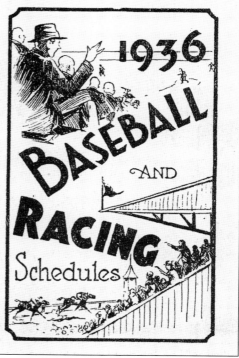

A rare find, a baseball and racing schedule shows the schedule for the racing dates of all of the racetracks open in Maryland. It also gave the dates for baseball games, thereby assuring the sports fan could plan accordingly. (Courtesy Andy Cashman.)

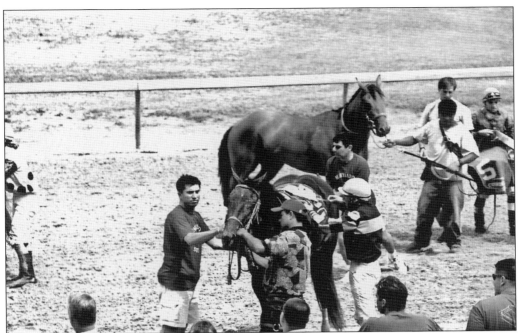

Horses are untacked and taken back to the stables. Other than the sales, the fair is the only time of the year that there are horses on the track at Timonium. (Courtesy Edie Bernier.)

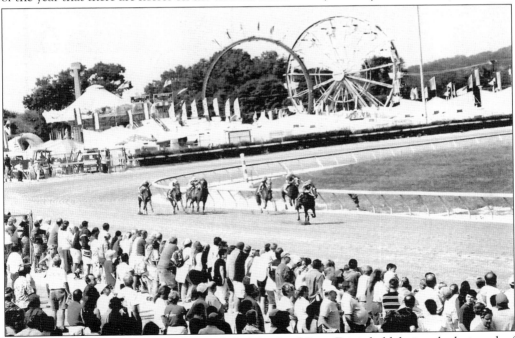

Billed as "The Ten Best Days of Summer," the Maryland State Fair is held during the last week of August, concluding on Labor Day. Thoroughbred racing is still an exciting part of that Maryland tradition. It is the only time during the year that the Timonium Race Track hosts Thoroughbred racing. (Courtesy Edie Bernier.)

In front of the grandstands, a lone outrider waits to escort his charge. It is hard to believe, looking at this modern site, that in earlier years, race results from the Timonium Race Track were communicated to horsemen in Baltimore and Virginia by carrier pigeon. (Courtesy Edie Bernier.)

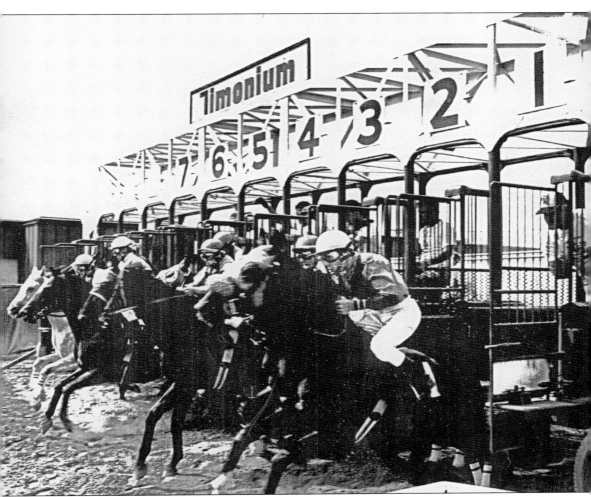

Horses out of the gate are always an exciting sight. The track comes alive with the pounding of hooves at the Maryland State Fair, held at Timonium Race Track. In the 1970s, the Maryland Racing industry wanted to have Timonium's racing dates transferred to other Maryland race tracks. Everyone recognized that this move would have a huge impact on fair attendance. The Committee of Friends of the Maryland State Fair was formed, and the fair was allowed to keep the dates during the state fair open for racing. (Courtesy the Maryland State Fair.)

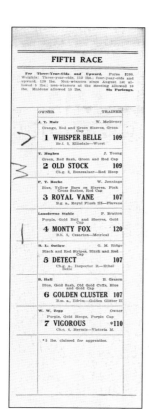

FIFTH RACE

For Three-Year-Olds and Upward. Purse $200.
Weights: Three-year-olds, 112 lbs.; four-year-olds and upward, 129 lbs. Non-winners since August 1st allowed 5 lbs.; non-winners at the meeting allowed 10 lbs. Maidens allowed 15 lbs. **Six Furlongs.**

OWNER	TRAINER
J. T. Muir	W. McGivney

Orange, Red and Green Sleeves, Green Cap

1 WHISPER BELLE 109
Br.f. 3, Ellisdale—Worst

T. Hughes — J. Young
Green, Red Sash, Green and Red Cap

2 OLD STOCK 109
Ch.g. 3, Rensselaer—Red Hoop

P. T. Roche — W. Jennings
Blue, Yellow Bars on Sleeves, Pink Cross Sashes, Red Cap

3 ROYAL VANE 107
B.g. a., Royal Flush III—Flavane

Lansdowne Stable — P. Bratton
Purple, Gold Belt and Sleeves, Gold Cap

4 MONTY FOX 120
B.h. 3, Cesarion—Metrical

R. L. Outlaw — G. M. Ridge
Black and Red Stripes, Black and Red Cap

5 DETECT 107
Ch.g. a., Inspector B.—Ethel Belle

B. Hall — B. Grason
Blue, Gold Sash, Old Gold Cuffs, Blue and Gold Cap

6 GOLDEN CLUSTER 107
B.m. a., Bdrim—Golden Glitter II

W. W. Zepp — Owner
Purple, Gold Hoops, Purple Cap

7 VIGOROUS *110
Ch.c. 4, Hermis—Victoria M.

* 5 lbs. claimed for apprentice.

One wonders if the 1, 2, and 3 on the left-hand side of the racing program were the results of the fifth race or someone's "pick" in the fall of 1913. (Courtesy Andy Cashman.)

As seen on the back of the program, the betting rules spell out very clearly the rules and limitations of placing a bet at the Timonium Race Track. (Courtesy Andy Cashman.)

IMPORTANT NOTICE

Make all wagers EARLY. The Maryland State Fair and Agricultural Society is not responsible for incompleted transactions after PARI-MUTUEL machines are locked.

All mistakes in Pari-Mutuel Tickets must be rectified before the race at the Information Window. Located at Main Line Cashiers Window 34.

All claims must be made at the Pari-Mutuel Office within 30 minutes after Race is run.

No claims will be entertained for lost or destroyed Pari-Mutuel Tickets.

When buying PARI-MUTUEL TICKETS kindly provide the exact amount of purchase.

$10 Daily Double Tickets sold in Divisions—Main Line No. 2 (Cashiers Window No. 54). Mezzanine No. 1 (Window end of Division). Mezzanine No. 2 (Window end of Division).

$2 Daily Double Tickets sold in Divisions—Main Line No. 2 (Cashiers Windows 59-77). Mezzanine No. 1 (Cashiers Windows 115-120). Mezzanine No. 2 (Cashiers Windows 151-156).

Twin Doubles Tickets are sold in the same locations as the Daily Double.

PARI-MUTUEL WAGERING

When you wager to **WIN** — you collect only if your horse **finishes first.**

When you wager to **PLACE** — you collect only if your horse **finishes first or second.**

When you wager to **SHOW** — you collect if your horse **finishes first, second or third.**

SPECIAL NOTICE

This Association will not be responsible for lost or destroyed Pari-Mutuel tickets and reserves the right to refuse payment on torn or mutilated Pari-Mutuel tickets.

TICKET NUMBER

Be sure that the number of your ticket corresponds with the Pari-Mutuel numbers opposite the horse's name on the program.

Do Not Destroy Pari-Mutuel Tickets Until Result Is Official

OUTSTANDING TICKETS

Outstanding Pari-Mutuel tickets will be cashed until the 4th Race at Previous Days Windows, situated on the main floor. Main Line No. 1, Windows 1-3-6-10-17-18-23.

POSITIVELY NO EXCHANGE OF TICKETS

6th Day—Saturday, August 29, 1964

The Timonium Race Track was always easy to get to. Just minutes from downtown Baltimore and right on the railway, it attracted many people who loved to follow Thoroughbred horse racing. It also attracted many more people for the annual state fair. In 1918, the first air mail delivery in the United States was made at the Timonium Fairgrounds. The Ice Review, shown here, was another crowd pleaser. (Courtesy Andy Cashman.)

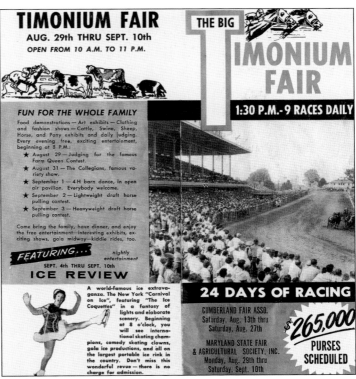

Gentlemen take a break at the Timonium Race Track. (Courtesy the Maryland State Fair.)

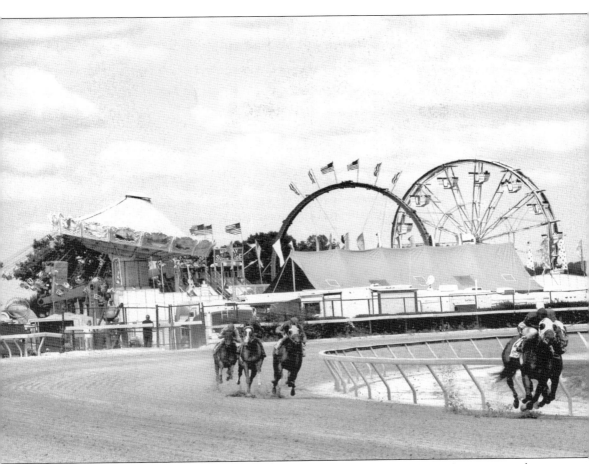

Ferris wheels and Thoroughbred racing are a sure sign of summer in Maryland. Known as the home of the Maryland State Fair, the fairgrounds also hold many trade and consumer shows. Thoroughbred racing is still a favorite, with attendance peaking at about 600,000 during the fair. (Courtesy Edie Bernier.)

PRIZES DONATED BY
COURTESY OF
BOWIE AND HAVRE DE GRACE RACE TRACKS

MARYLAND JOCKEY CLUB YEARLING SHOW

FOR THOROUGHBRED YEARLINGS

COLTS AND FILLIES

FOALED IN MARYLAND

Pimlico, Thursday, May 9th, 1935, 10 a. m.

JUDGE

JAMES F. FITZSIMMONS

Bowie Race Track was not allotted the best racing dates in Maryland, but it rose to the challenge by supplementing the racing season with other events, such as the Yearling Show. (Courtesy Enoch Pratt Free Library.)

The founders chose a site between Baltimore, Washington, and Annapolis that was also right next to the electric rail line. It made it very easy for workers from the three large cities to get to the track. (Courtesy Enoch Pratt Free Library.)

Youngest of Maryland's three-mile tracks, Bowie was first known as Prince George's Park. Havre de Grace, Laurel, and Pimlico already had all of the desirable racing dates. The only dates left were in the middle of Maryland's hot, humid summer or in the middle of Maryland's cold, often freezing winter. The site was always described as functional but not comfortable. (Courtesy Bill Beehler.)

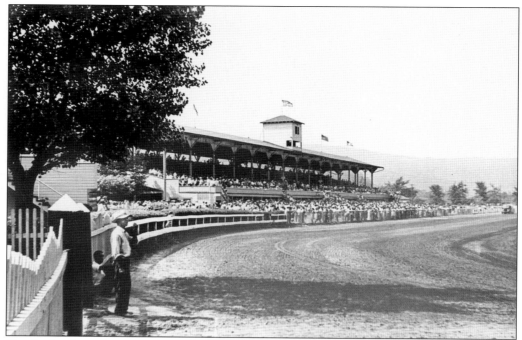

Cumberland was known as one of the most beautiful tracks in Maryland. Cumberland was a welcome oasis on the track circuit. One hundred and twenty-five acres off McMullen Highway, "Fairgo" was founded in 1924 by the stock holders of the Cumberland Fair Association. (Courtesy Maryland Horse Breeders Association.)

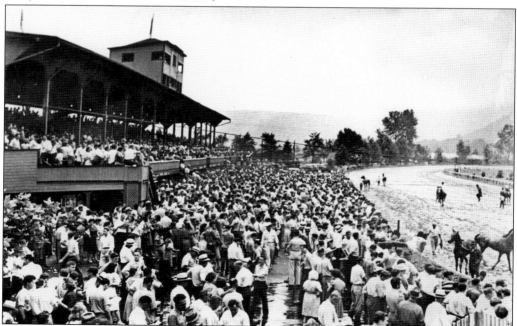

Meets ran in conjunction with the fair, which lasted five days. Purses averaged $300 to $400. (Courtesy Maryland Horse Breeders Association.)

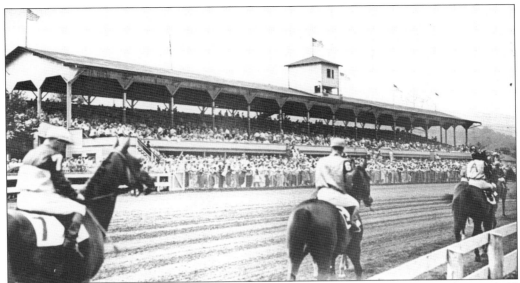

In the order of the circuit, Timonium was first, then Marlboro, then Cumberland. It took 12 to 16 Baltimore and Ohio Railroad cars to transport the horses from Marlboro to Cumberland. The train would depart on Saturday evening and arrive in Cumberland 14 hours later on Sunday morning. The facility boasted 300 stalls, but in the 1940s and 1950s, tents were brought in to house more horses. Just down Route 200 lay the small town of Cumberland. (Courtesy Maryland Horse Breeders Association.)

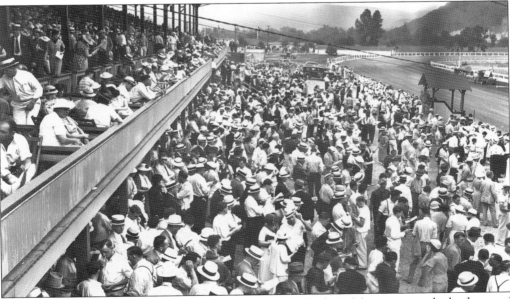

The picturesque setting of lush fields and the beautiful Allegheny Mountains in the background gave one the feeling of being on vacation. Crowds could swell from 20,000 to 25,000. The biggest day was Governor's Day, when the governor would come in from Annapolis to attend the races. Cumberland was the first half-mile track in Maryland to go under. In 1961, racing dates were moved to Timonium Race Track. Today, the track is being used for auto racing. (Courtesy Cappy Jackson.)

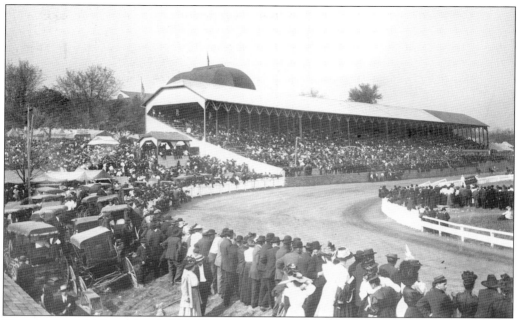

Hagerstown, which used to hold half-mile meets, now stables horses for nearby Charlestown Racetrack, located in West Virginia. Fairs were held at this lovely track for a few years, but it closed in the early 1880s. Races had purses from $200 to $300, a good-size purse for the time. (Courtesy Cappy Jackson.)

The track was described as a full half-mile nearly elliptical in form with easy curves and mostly level. By the 1930s, racing had become an added attraction at the fairgrounds. Hagerstown was a favorite of the jockeys and trainers who traveled the circuit because of its homey feel. It was a very rural location without the benefit of local motels, so jockeys, track officials and trainers would often stay in private homes. The track kitchen was described by one as "the best track kitchen on the circuit." Attendance dropped when nearby Charlestown opened. (Courtesy Maryland Horse Breeders Association.)

HAGERSTOWN FAIR

HAGERSTOWN, MD.

First Exhibit

Programme of

RUNNING RACES

May 19, 20, 21, 22, 23,

1936

Hagerstown's fair was enjoyed by all, with Thoroughbred racing as the highlight. (Courtesy Enoch Pratt Free Library.)

SCALE OF WEIGHT FOR AGE

Distance	Age	May
Half Mile	2 years	87
	3 years	116
	4 years	126
	5 years and over	126
Six Furlongs	2 years	90
	3 years	119
	4 years	130
	5 years and over	132
One Mile	2 years	
	3 years	112
	4 years	127
	5 years and over	128
One Mile and a Quarter	2 years	
	3 years	108
	4 years	127
	5 years and over	127
One and a Half Miles	3 years	105
	4 years	127
	5 years and over	128
Two Miles	3 years	102
	4 years	126
	5 years and over	128
Three Miles	3 years	97
	4 years	127
	5 years and over	128

35

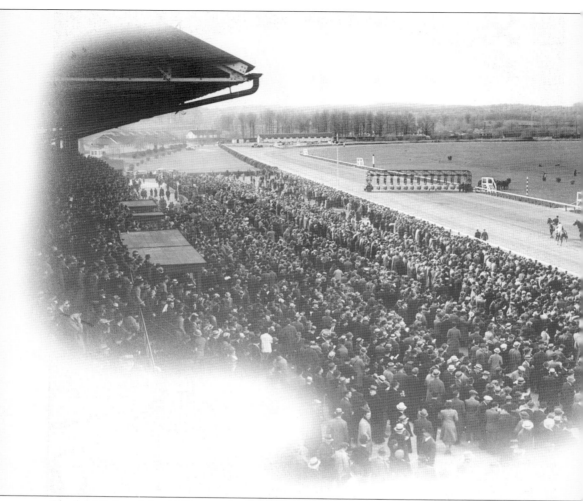

The highlight of the 1940s was Citation racing in the Chesapeake Stakes. Citation had won his maiden start at Havre de Grace, but a win on April 12, 1948, was not to be. Citation lost to Saggy, owned by Baltimorean Stanley Sagner. Eddie Arcaro was aboard Citation. (Courtesy Keeneland Library.)

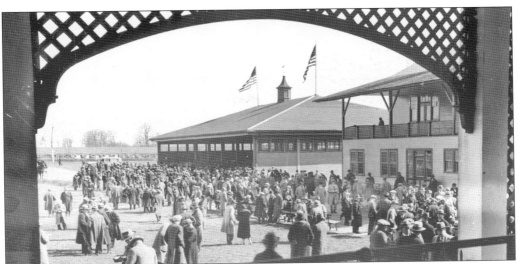

In the very northernmost part of the Chesapeake Bay by the Susquehanna River, a track known as "The Graw" flourished. Havre de Grace was the other Maryland miler back when Maryland only had four one-mile race tracks. Havre de Grace was the first mile track in the state to close. Havre de Grace first opened in 1912. Originally built as a part of the county fair racing circuit, the track had room for over 500 horses, as well as living quarters for jockeys, trainers, and owners. (Courtesy Maryland Horse Breeders Association.)

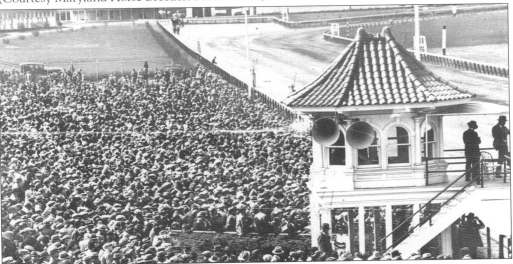

Owned by August Belmont, Havre de Grace opened its doors to 5,000 to 6,000 spectators at a cost of $1 per person. During the early years, Havre de Grace ran under the auspices of the Harford County Racing Commission until 1920, when the Maryland Racing Commission was formed. The four one-mile tracks at that time were Havre de Grace, Bowie, Pimlico, and Laurel. One of the most notable events in the track's history was the arrival of Man o'War in 1920. Entered in the Potomac Handicap, the featured race was said to one of the best of his career. The Roaring Twenties were the heyday of the Graw, but by 1934, things were getting dark for the track. Entries were down, and often racing secretary Charles McLennan had to go out daily and round up enough horses to hold many of the meets. Many of the horses were not fit enough to run the half-mile, let alone the full mile.

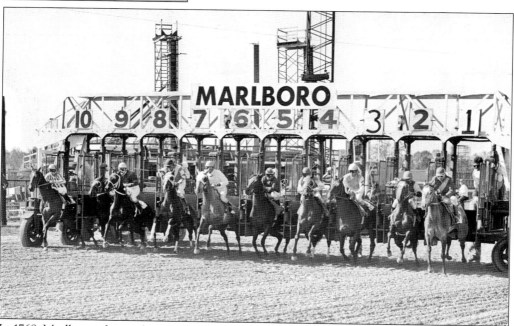

Located in Prince George's County, Marlborough had meets recorded as early as 1745. Races were held there by the Maryland Jockey Club, but the exact location of the early site is not known. (Courtesy Bill Beehler.)

In 1768, Marlborough was the site of the century's most celebrated match race when the imported Figure, owned by Dr. Thomas Hamilton, defeated American-bred Selim. (Courtesy Maryland Horse Breeders Association.)

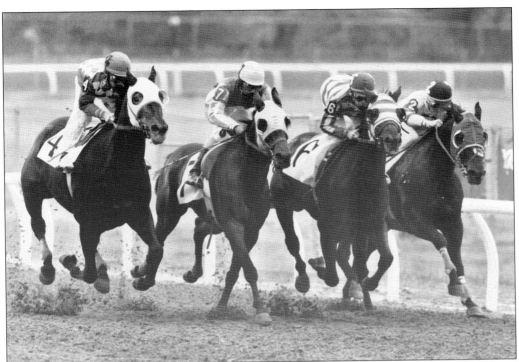

Marlborough continued its racing career as part of the half-mile racing fair circuit. The fair, as in many of the small rural counties where they were held, was the event of the year. Unfortunately, this small track is known more for its political scandal than for its racing. The track closed for good in 1971. (Courtesy Maryland Horse Breeders Association.)

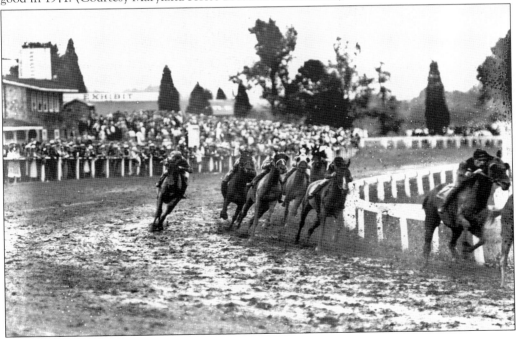

Many programs become treasured souvenirs, marked with races won or simply a token of a fondly remembered day. (Courtesy Enoch Pratt Free Library.)

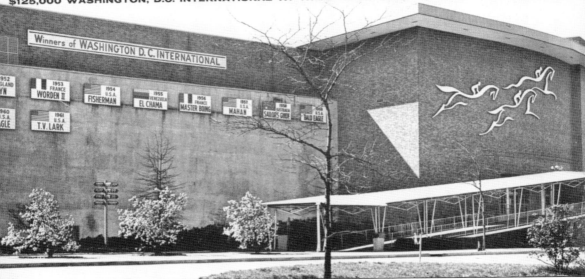

Laurel hosted many prominent races, the most prestigious of which was the Washington, D.C. International. The glamorous 1961 International Ball, which preceded the race, was not only fun but a charity fund-raiser. The white-tie affair drew its guest list from the elite of the racing and society worlds and the diplomatic corps. The rows of flags represent the horses from various nations that will be competing. (Courtesy Maryland Jockey Club and Enoch Pratt Free Library.)

Resolutions Adopted By The Citizens Committee On Race Track Gambling, March 6, 1914, At A Meeting In The City Club.

WHEREAS, we recognize the immoral influences of race track gambling upon the army of clerks and other employes of business organizations, the economic waste of capital withdrawn from circulation in the city, the time, attention and best efforts of a multitude of employes spent in following the races, not only while they are being run in Maryland, but through the pool rooms from one year's end to the other; therefore be it

RESOLVED, that we, as business men, hereby record our unalterable opposition to the bill now before the Legislature (or any like bill that may be introduced), proposing to license race tracks and race track gambling under a State Commission, to secure revenue for the State roads, or for any other purpose; and that we urge the Finance Committee of the Senate to report such bill unfavorably.

RESOLVED secondly, that we register our earnest conviction that a State-wide Anti-Race-Track-Gambling bill should be passed by our present Legislature, and that we urge the Legislators to work and vote for such a measure.

RESOLVED thirdly, that we request the Committee on Judicial Proceedings of the Senate to grant our Committee a public hearing on the Racing bills.

EDWIN WARFIELD,	WM. H. MATTHAI,	J. BARRY MAHOOL,
A. R. L. DOHME,	PHILEMON H. TUCK,	JOHN T. STONE,
ROBT. GARRETT,	M. C. WOODWARD,	JOSHUA LEVERING,
THEO. K. MILLER,	C. J. B. SWINDELL,	CHAS. W. DORSEY,
WM. B. HURST,	BENJ. W. CORKRAN, JR.,	JOHN D. HOWARD,
IRA REMSEN,	H. FINDLAY FRENCH,	T. DAVIS HILL,
J. M. T. FINNEY,	SUMMERFIELD BALDWIN,	THOMAS MACKENZIE,
JOHN R. BLAND,	ELMORE B. JEFFERY,	WILLIAM ROSENAU,
F. H. BAETJER,	JOHN T. GRAHAM,	EDWARD C. WILSON,
WM. F. COCHRAN,	SEWELL S. WATTS,	JOSIAH CLIFT, JR.,
CHAS. J. BONAPARTE,	JAMES CAREY, JR.,	GEORGE W. CORNER,
RANDOLPH BARTON,	WM. H. FEHSENFELD,	EDMUND C. WHITE, JR.,
MILES WHITE, JR.,	DeCOURCEY W. THOM,	C. B. DALLAM,
WM. M. ELLICOTT,	EDWIN L. TURNBULL,	H. G. EVANS,
HENRY F. BAKER,	ISAAC S. FIELD,	JOHN BLACK,
ROBT. W. JOHNSON,	JORDAN STABLER,	JOHN E. SEMMES, JR.,
W. H. MALTBIE,	HENRY F. BAKER,	E. ALLEN LYCETT,
BERNARD BAKER,	H. S. DULANEY,	RICHARD P. BAER,
CHAS. E. FALCONER,	J. H. MASON KNOX, JR.,	JOHN MARTIN VINCENT,
J. HALL PLEASANTS,	CHAS. D. FENHAGEN,	JOHN W. MEALY,
FRANCIS A. WHITE,	A. R. CATHCART,	W. O. ATWOOD,
ELISHA H. PERKINS,	EDW. GUEST GIBSON,	THOMAS E. BOND,
FREDERICK COLSTON,	W. C. VANSANT,	T. M. SNOWDEN,
C. ERNEST BAKER,	JAMES CAREY,	CALEB J. MOORE,
ROBERT L. MOORES,	DANIEL BAKER,	CHAS. T. BAGBY,
F. E. WATERS,	W. S. WALKER,	JOHN S. BRIDGES,
H. A. ORRICK,	HOWARD P. SADTLER,	J. MILTON LYELL,
CHAS. J. TAYLOR,	DOUGLAS H. ROSE,	J. W. VALIANT,
SAM'L G. B. COOK,	JONATHAN K. TAYLOR,	CASWELL GRAVE,
EDW. L. ROBINSON,	EDWARD STINSON,	T. T. TONGUE,
CHAS. O. SCULL,	W. GISRIEL, JR.,	EUGENE LEVERING,
GEORGE M. GAITHER,	HENRY P. BRIDGES,	CHAS. J. BOLGIANA,
GEORGE C. THOMAS,	JOHN L. ALCOCK,	THEODORE HETRICK.
GEORGE MILLER,	WM. H. MORRISS,	

Write to your Representative in the Legislature on this subject.

The more things change, the more they stay the same. In 1914, a group of concerned, prominent citizens formed its own committee to protest race track gambling. They feared "the immoral influences of race track gambling upon the army of clerks and other employes [sic] of business organizations, the economic waste of capital withdrawn from circulation in the city, the time, attention and best efforts of a multitude of employes spent in following the races . . . not only in Maryland, but through the pool rooms from one year's end to the other." (Courtesy authors' collection.)

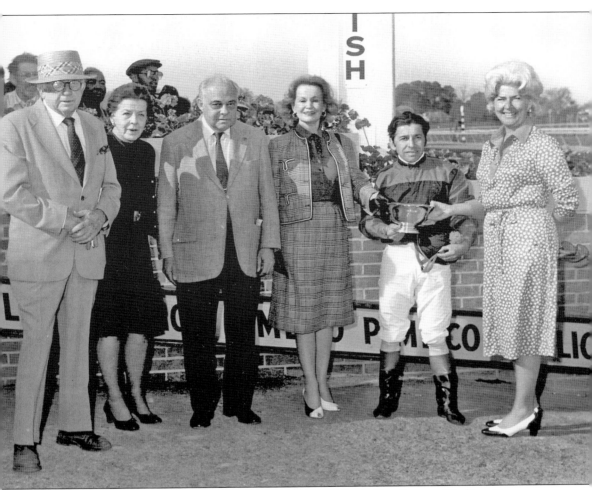

Marquee Universal won the 79th running of the $118,700 Dixie Handicap at Pimlico. He won the mile-and-a-half race on the grass by four lengths. Pictured are Mr. and Mrs. Alec Bullock (trainer), Mr. and Mrs. Gerald Freed (owners), Hector Pilar (jockey), and Mrs. Chick Lang (wife of Pimlico's general manager). (Courtesy Richard F. Blue Jr.)

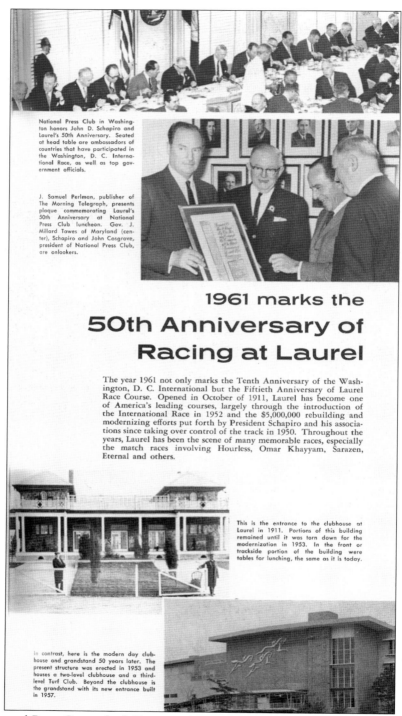

National Press Club in Washington honors John D. Schapiro and Laurel's 50th Anniversary. Seated at head table are ambassadors of countries that have participated in the Washington, D. C. International Race, as well as top government officials.

J. Samuel Perlman, publisher of The Morning Telegraph, presents plaque commemorating Laurel's 50th Anniversary at National Press Club luncheon. Gov. J. Millard Tawes of Maryland (center), Schapiro and John Cosgrove, president of National Press Club, are onlookers.

1961 marks the
50th Anniversary of Racing at Laurel

The year 1961 not only marks the Tenth Anniversary of the Washington, D. C. International but the Fiftieth Anniversary of Laurel Race Course. Opened in October of 1911, Laurel has become one of America's leading courses, largely through the introduction of the International Race in 1952 and the $5,000,000 rebuilding and modernizing efforts put forth by President Schapiro and his associations since taking over control of the track in 1950. Throughout the years, Laurel has been the scene of many memorable races, especially the match races involving Hourless, Omar Khayyam, Sarazen, Eternal and others.

This is the entrance to the clubhouse at Laurel in 1911. Portions of this building remained until it was torn down for the modernization in 1953. In the front or trackside portion of the building were tables for lunching, the same as it is today.

In contrast, here is the modern day clubhouse and grandstand 50 years later. The present structure was erected in 1953 and houses a two-level clubhouse and a third-level Turf Club. Beyond the clubhouse is the grandstand with its new entrance built in 1957.

By 1961, Laurel Race Course had 50 years of prominent racing to its credit. Located midway between Baltimore and Washington, D.C., the course drew crowds and competitors from all around the East. (Courtesy Maryland Jockey Club and Enoch Pratt Free Library.)

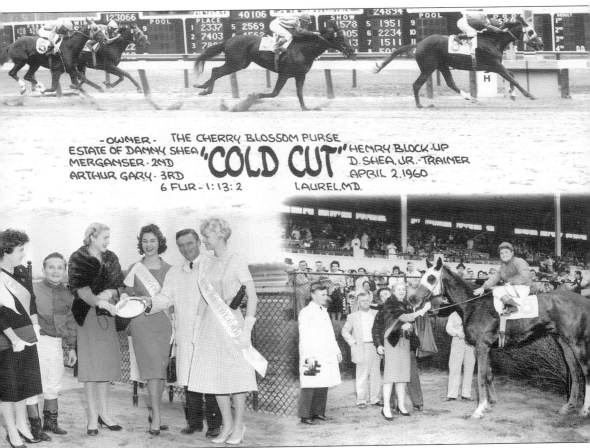

The process of coming up with a new name that hasn't already been used for a Thoroughbred can be frustrating. After several rejections by the Jockey Club in New York, Mrs. Betty Shea was pondering a new one when her husband, Danny, announced that the colt had just been "cut" (gelded). Seizing the moment, while securing the name, the horse was known as "Cold Cut." Mrs. Shea notes that all the butchers always bet on him. (Courtesy Betty Shea Miller.)

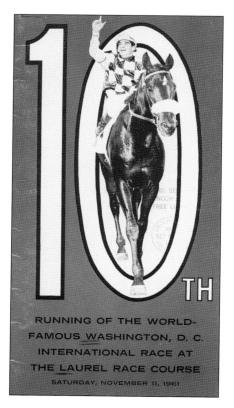

RUNNING OF THE WORLD-
FAMOUS WASHINGTON, D. C.
INTERNATIONAL RACE AT
THE LAUREL RACE COURSE
SATURDAY, NOVEMBER 11, 1961

The year 1961 marked the 10th anniversary of the running of the Washington, D.C. International at Laurel. Immensely popular, it helped usher in not only the jet age, but also the jet set. With the advent of easy air travel, the racing world was opened up. People and horses could now fly to meets in other countries. Devotees of the sport could "pop across the pond." This was the first truly international race, and it set a precedent for those that followed. (Courtesy Maryland Jockey Club and Enoch Pratt Free Library.)

Laurel Race Course boasted state-of-the-art technology to ensure a safe and honest racing and wagering environment. From video cameras to drug testing to security guards, the track touted its efforts. (Courtesy Maryland Jockey Club and Enoch Pratt Free Library.)

Two

FARMS AND FURLONGS

Laural

Laurel, located in the verdant Green Spring Valley, was home to Col. and Mrs. Ral Parr. The estate consisted of 500 acres of pasture, woods, and water. There were large barns and numerous dependencies. Parr was one of the leading horsemen of his era, and many champions wore his silks, including the 1920 Kentucky Derby winner, Paul Jones. (Courtesy authors' collection.)

There is a reason why racing has always been called "the sport of kings." It's rather expensive. Consequently, anyone interested in being an owner should either have deep pockets or marry well. During the glory days of racing, owners maintained an opulent lifestyle, of which the racing was only a facet of the overall tableau. (Courtesy authors' collection.)

Gracious homes that were beautifully furnished, valuable art and silver, extensive libraries stocked with leather-bound volumes with cut pages, and lavish entertaining on both an intimate and grand scale were all aspects of the lifestyle. (Courtesy authors' collection.)

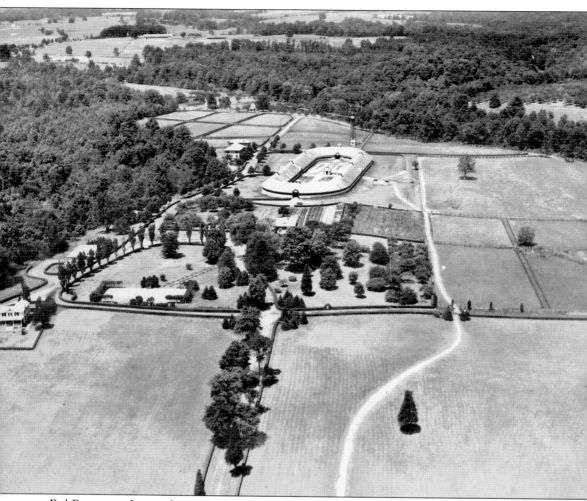

Ral Parr owned several expensive properties, and one of them was the magnificent Laurel Park Farm, located near Laurel Race Course. Visitors (both equine and the human variety) could arrive via railroad, debarking at the farm's very own private siding. The 373 acres included 82 box stalls, a covered "four times around" track, a mile track, an eighth-of-a-mile straightaway, and two enormous water tanks—10,000 and 3,000 gallons respectively. There were 14 fenced paddocks, several of which were 50 acres apiece. (Courtesy authors' collection.)

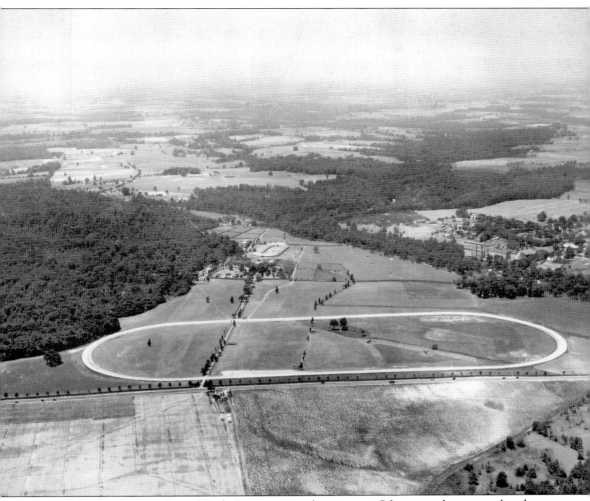

None of the paddocks at Laurel Park Farm were under an acre. Of course, there was also the mandatory manor house, numerous servants' quarters and other outbuildings, sheds, and storehouses. The roads connecting the various areas were all paved and meandered by orchards, pastures, and gardens. (Courtesy authors' collection.)

The Maryland Horse Breeders Annual Awards Dinner was and is an event not to be missed by those involved in the industry of Maryland Thoroughbred racing. It honors those who excel in this field each year. (Courtesy Maryland Horse Breeders Association.)

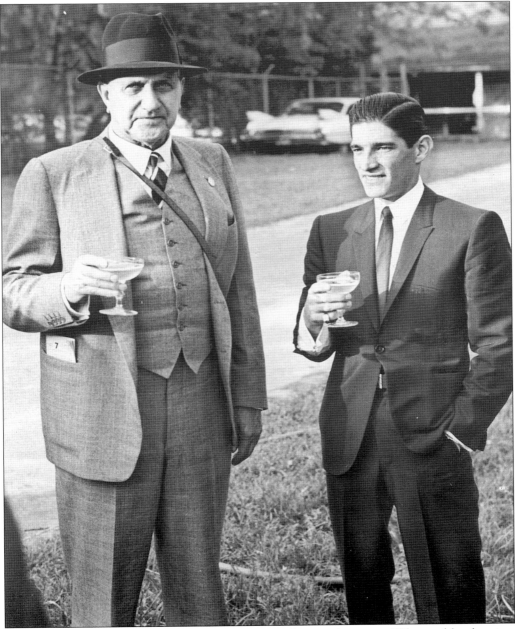

Mr. Guggenhiem, on the left, is seen here enjoying the social aspect of Thoroughbred racing. (Courtesy Maryland Horse Breeders Association.)

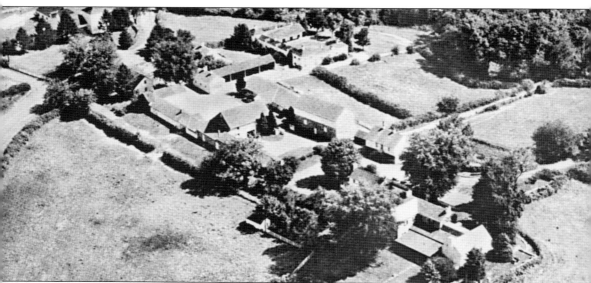

An aerial photograph of Glenangus Farm shows a rare glimpse of the farm owned by Larry S. MacPhail. Glenangus is most noted as home to Carry Back's sire Saggy. Saggy, owned by Stanley Sagner, in 1947 had the remarkable distinction of being undefeated as a two-year-old and set a world record for four-and-a-half furlongs at Havre de Grace. Glenangus was also the birthplace of Riva Ridge's dam Iberia. Glenangus maintained a strong presence in Harford County for more than 20 years. (Courtesy Maryland Horse Breeders Association.)

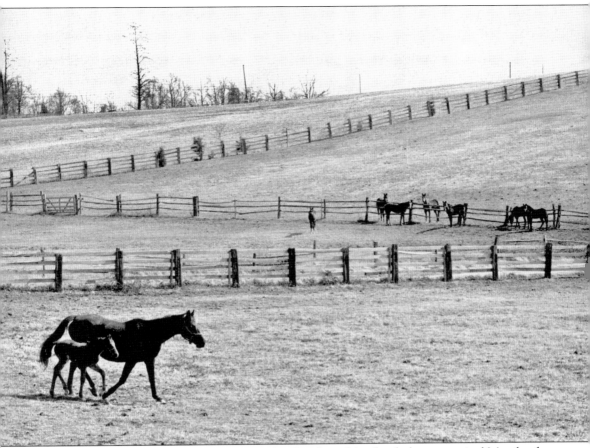

Beautiful, picturesque Roedown Farm, located in Southern Maryland, shows a typical Maryland scene, mares and foals peacefully grazing at home. Roedown Farm was home to many stakes winners, such as Pochette, during its career. (Courtesy Maryland Horse Breeders Association.)

Sagamore, one of the most beautiful farms past or present and located in Worthington Valley in Baltimore County, began as a 21st birthday present. (Courtesy authors' collection.)

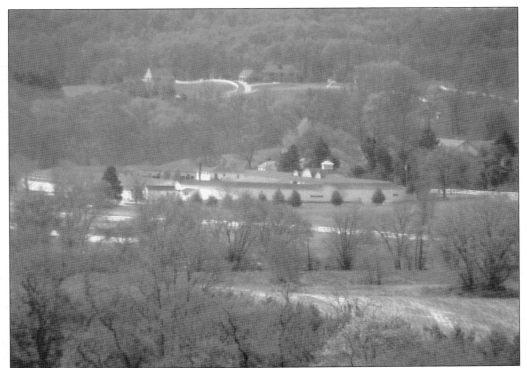

Mrs. Margaret Emerson Vanderbilt Amory, heiress to the Bromo-Seltzer fortune, gave the original portion of Sagamore Farm on September 22, 1933, as a 21st birthday present to her son, Alfred G. Vanderbilt. She also turned over all of her racehorse holdings. (Courtesy authors' collection.)

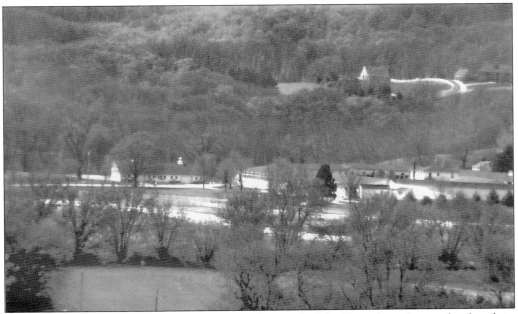

Set on gently rolling hills, the red roofs and white-washed buildings have been a landmark in Worthington Valley for over three quarters of a century. (Courtesy authors' collection.)

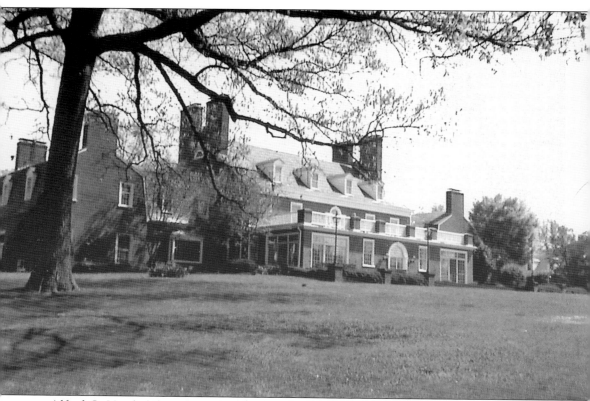

Alfred G. Vanderbilt was very involved in the business of Sagamore. Shown here, his former residence is right across the road from the farm. (Courtesy authors' collection.)

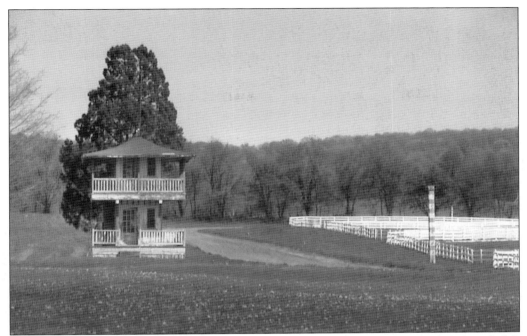

The Clocker's Tower, the quaint building in the foreground, is the vantage site where Mr. Vanderbilt would watch the progress and training of his horses. The two-story structure overlooked the outside track and was a comfortable spot to "clock" the speed of horses passing in front of the striped furlong marker. (Courtesy authors' collection.)

Shown in the background, a lone run-in shed provides shelter for horses in retirement to come and go as they pleased, living a leisurely life once they retired from racing. (Courtesy authors' collection.)

In the foreground, the blacksmith shop keeps horses' feet trimmed and shod. In the background, the original living quarters for grooms and exercise riders are shown. (Courtesy authors' collection.)

The indoor training track shown in the background was modeled after the one built at Bowling Brook. This allowed the horses to be worked all year in any kind of weather. (Courtesy authors' collection.)

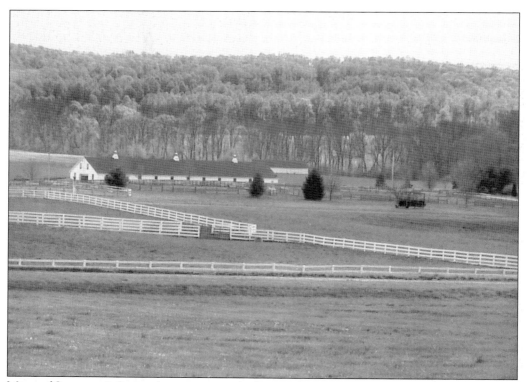

Many of Sagamore's famous horses are now laid to rest here. Native Dancer and his son, Restless Native, as well as Bed of Roses all are buried at Sagamore. (Courtesy authors' collection.)

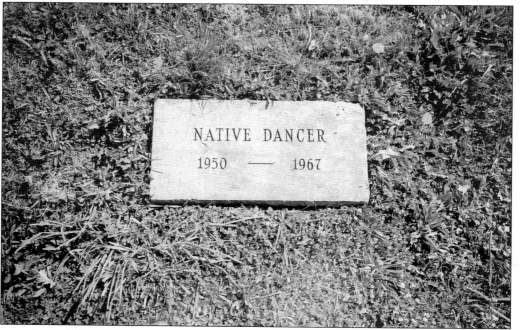

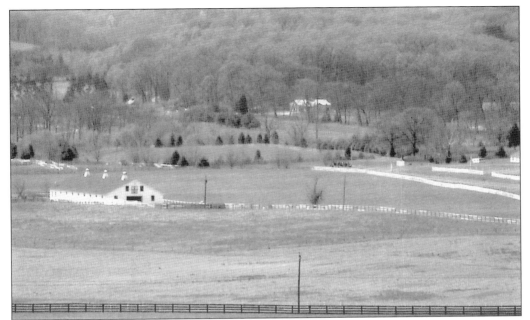

Still beautiful, picturesque, and operational, Sagamore has scaled down its holdings since the days of Mr. Vanderbilt. (Courtesy authors' collection.)

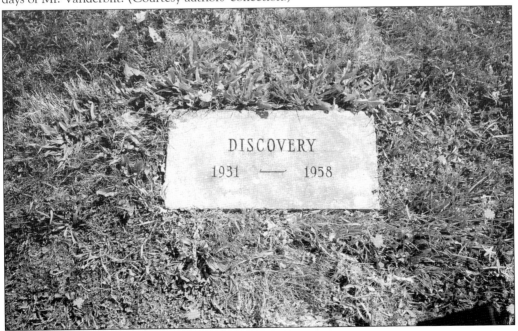

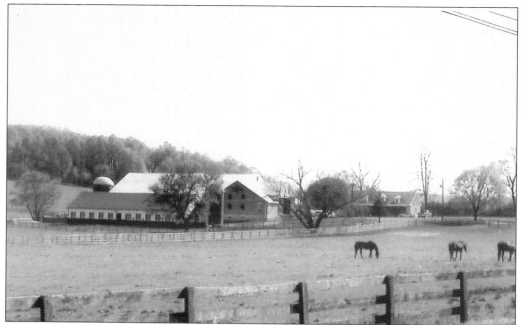

Worthington Farms is located directly across from Sagamore Farms in Baltimore County. Marcel LeMasson, the farm manager, would frequently walk mares from Worthington Farms to Sagamore to be bred. Yes You Will and Assemblyman lived at the farm. (Courtesy authors' collection.)

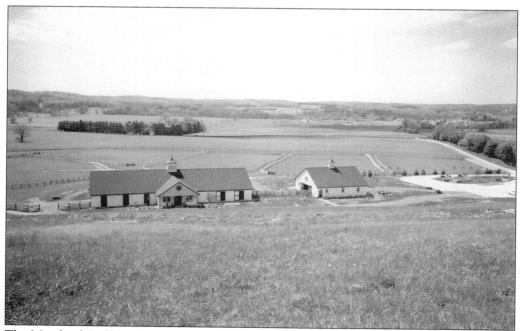

The Maryland Stallion Station, a new chapter in Maryland's Thoroughbred history, is located on 100 acres overlooking Sagamore Farm in Worthington Valley and is on land that was once a part of the Sagamore Farm. (Courtesy authors' collection.)

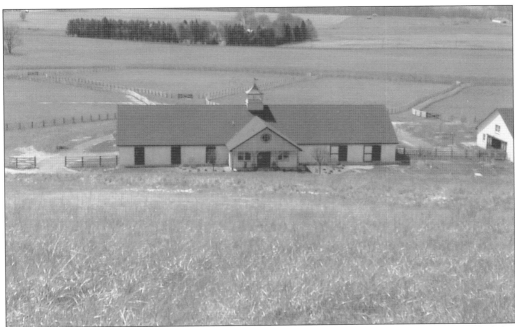

Although it is across the street from Sagamore, it is just down the hill from A. G. Vanderbilt's home. The Maryland Stallion Station is currently standing five exceptional stallions. Don Litz is the president of the Maryland Stallion Station. (Courtesy authors' collection.)

A stud fee is the fee an owner charges for breeding a stallion to a mare. Fees range from several hundred dollars to tens of thousands of dollars for a quality pedigree. (Courtesy Parker and Lee Watson.)

PISTORIO FARM

ROUTE 40 - BALTIMORE NATIONAL PIKE - RFD-2

ELLICOTT CITY, MD. OCTOBER 1, 19 53

Ira Knoll Farm
Manor Road,
Glen Arm, Md. Attention: Mr. David R. Watson, Mgr.

MAILING ADDRESS:

MAKE CHECKS PAYABLE TO: PISTORIO FARM 6522 FREDERICK RD. TELEPHONE: RI 7-9630
BALTIMORE 28, MD.

				STUD FEE		$100.00
SEASON BY	GOLDEN BULL		TO	SLIM MARGIN		
KEEP OF						
FROM	TO	AT	PER MONTH			
BLACKSMITH						
VETERINARY ACCOUNT						
SHIPPING EXPENSES						
DATE OF LAST SERVICE						
SUNDRIES						

As per verbal contract with Mrs. Samuel M. Pistorio

Paid.
11-7-53

What was Stymie Manor Farm, then Corbett, and is now Prospect Farm, located in Northern Baltimore County in the beautiful area of My Lady's Manor, has been home to many champions. Its rolling hills and lush pastures were admired by many. Stymie Manor was built in the 1940s by Hall of Fame trainer Hirsch Jacobs. (Courtesy authors' collection.)

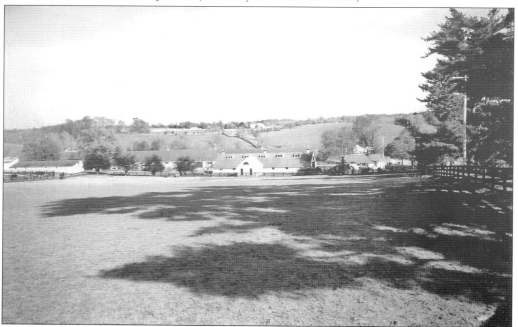

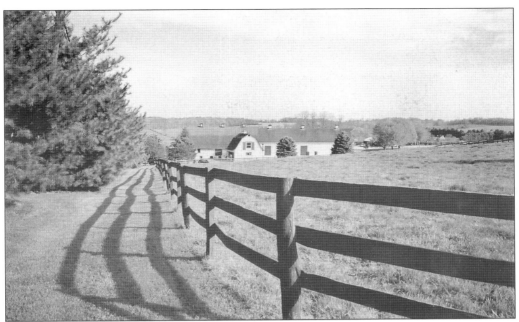

Hirsch Jacobs was the conditioner of Stymie. Jacobs only visited Stymie Manor three or four times a year, so beginning in 1956, the day-to-day operation was run by manager and trainer Bill Albright. Champions Personality, Hail to Reason, and Affectionately were all raised here. (Courtesy authors' collection.)

Ira Knoll Farm's
YEARLINGS

TO BE SOLD AT TIMONIUM NOV. 2, 1950--8 P. M.
MARYLAND HORSE BREEDERS ASS'N YEARLING SALES

THE 1950 PIMLICO YEARLING SHOW BLUE RIBBON WINNER
(Over 34 entrants)

JUDGE:
PAUL EBELHARDT of Calumet

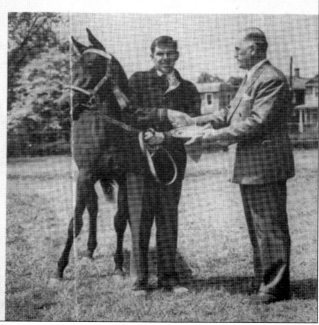

Gen. Reckord presenting trophy to Dave Watson after Mr. Ebelhardt pinned Blue Ribbon on "Blue Rhymer."

A small stable such as Ira Knoll was an around-the-clock operation for the family at particular times of the year. Everyone pitched in. They had to have a working knowledge of a wide range of equine-related issues, such as breeding, birthing, training, medicine, and mucking out the stalls. Once a year, they would offer yearlings at the sales at Timonium or elsewhere. (Courtesy Parker and Lee Watson.)

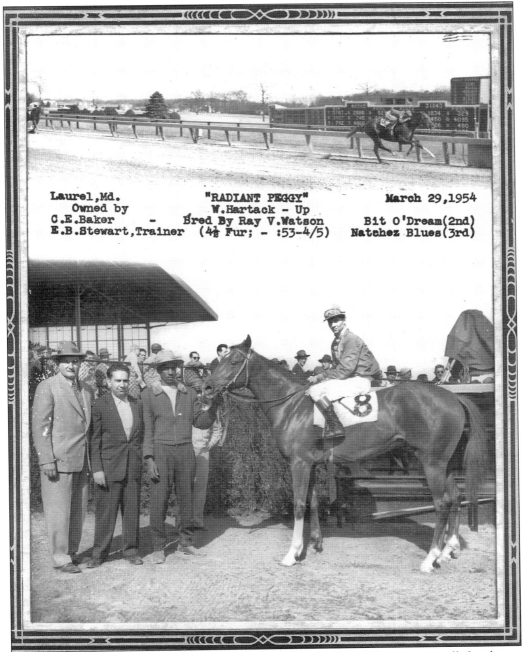

Laurel, Md. "RADIANT PEGGY" March 29, 1954
 Owned by W.Hartack - Up
C.E.Baker - Bred By Ray V.Watson Bit O'Dream(2nd)
E.B.Stewart, Trainer (4½ Fur; - :53-4/5) Natchez Blues(3rd)

Not all horse farms were large operations. Some, such as Ira Knoll Farm, were small, family-run enterprises. Irene and Ray Watson fulfilled a joint dream when they moved to Glyndon and started their 100-acre farm in the mid-1940s. Their winning horse, Radiant Peggy, was named for their daughter, Peggy. (Courtesy Peggy Watson Strott.)

The farm Bowling Brook, located in Middleburg, Carroll County, was the premier training facility in the country during the 18th century. Trainer R. Wyndham Walden trained Tom Ochiltree and won the 1875 Preakness. The team of owner George Lorillard and trainer Wyndham went on to five consecutive Preakness wins from 1878 to 1882. Walden won over 1,000 races, including the great three-horse stakes at Pimlico in 1877 for which Congress adjourned. This was the only time in American history that Congress adjourned for a sporting event. (Courtesy Maryland Horse Breeders Association.)

Bowling Brook, originally 1,000 acres, was a model for the farm Sagamore. Max Hirsch got his start here at age 12 as an exercise boy. Henry Clark leased Bowling Brook in the 1960s. The property was originally a land grant called Bedford given to Norman Bruce and Edward Diggs in 1763. (Courtesy Maryland Horse Breeders Association.)

The circular indoor training barn seen here was destroyed by fire in the early 1990s. (Courtesy Cappy Jackson.)

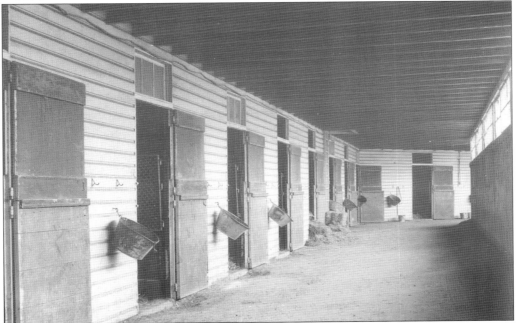

Bowling Brook was described as a one-fifth circular track with lush, limestone-rich grass, which makes the horses strong. Walden had his own box car that took horses from the farm to the track. George Lorillard had a spur built off the main line to Middleburg so horses could be walked from Bowling Brook right to the train, still wearing their purple blankets with the white "W." (Courtesy Cappy Jackson.)

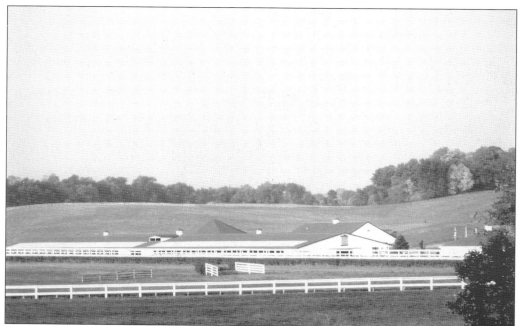

Bonita Farm, owned and operated by the Boniface family, is located in Harford County in the town of Darlington, in the heart of the Mid-Atlantic Region. The dream of Bill and Joan Boniface began on a modest 40-acre farm in Bel Air. (Courtesy the Boniface family.)

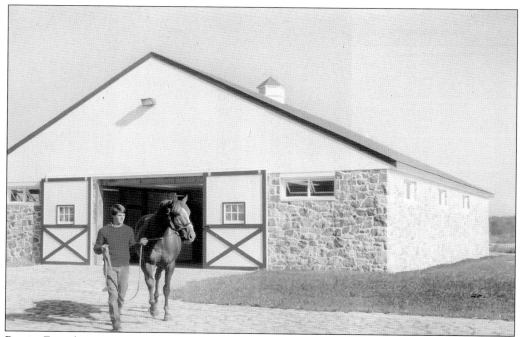

Bonita Farm boasts extensive facilities for its operations, including 156 stalls, 235 acres of pasture, a five-eighths-mile track, and a half-mile turf track. (Courtesy the Boniface family.)

All of the buildings at Bonita Farm are immaculately maintained, both inside and out. Pictured here is the office. (Courtesy the Boniface family.)

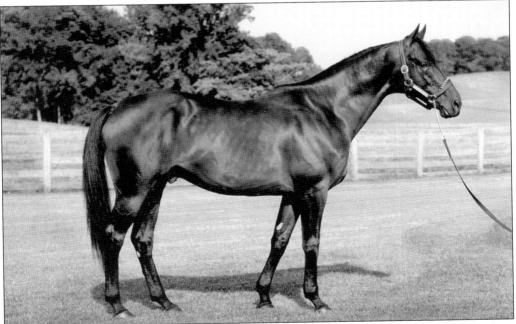

Deputed Testamony is completely a product of Bonita Farm. He was foaled in 1980 at the farm and spent his first summer with his dam in the broodmare barn. After becoming a two-year-old on January 1, 1982, he was moved to the training barn and broken to become a racehorse. Deputed Testamony's splendid racing record of nine wins and earnings of $626,154 out of 18 career starts is extraordinary. He won the Preakness Stakes in 1983. (Courtesy the Boniface family.)

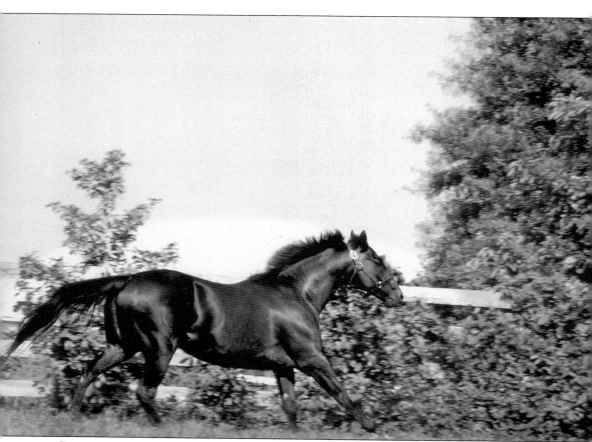

Bonita Farm is unusual in that you will see Thoroughbreds in all phases of their life career. Broodmares, foals, yearlings, weanlings, stallions, and horses in retirement all have a home at Bonita Farm. (Courtesy the Boniface family.)

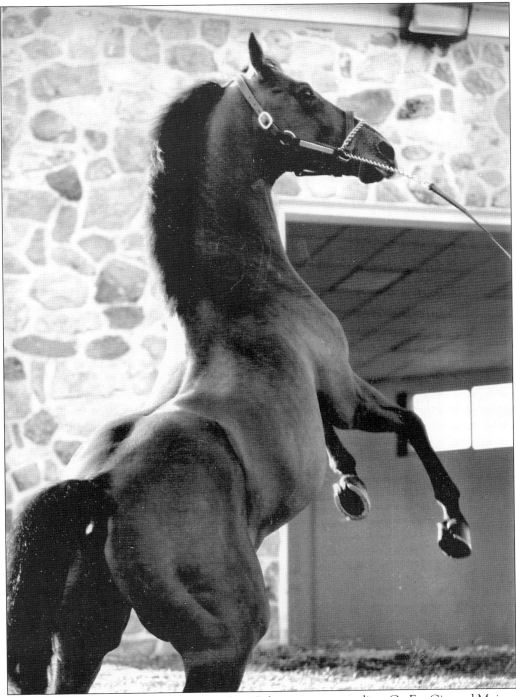

Among the many stallions at Bonita, as of 2005 there are two standing, Go For Gin and Mojave Moon. (Courtesy the Boniface family.)

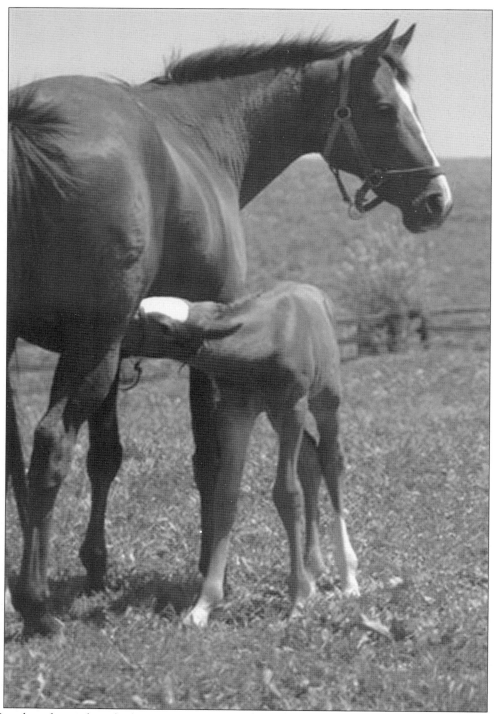

Many broodmares have had a successful turn at the track before they launch into a second career as broodmares. A successful broodmare can be a moneymaker for its owner, as well as strengthening the line to produce fast, sound, and sturdy offspring. (Courtesy Ellen B. Pons.)

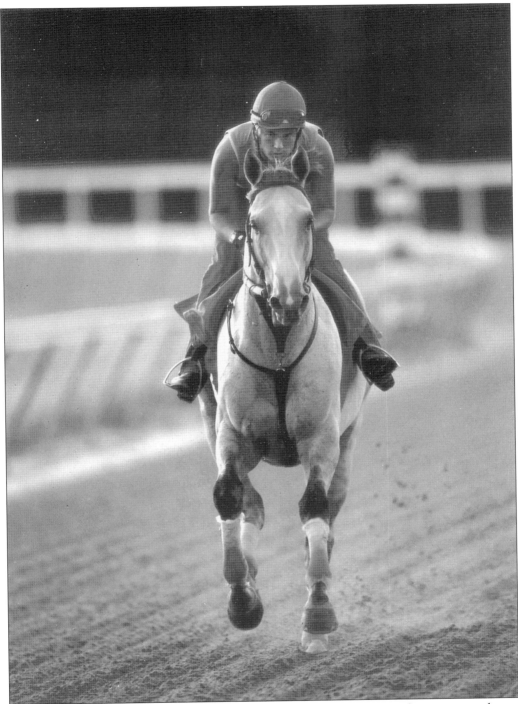

A young horse in training gets a workout and learns more about his new profession as a racehorse.
(Courtesy Ellen B. Pons.)

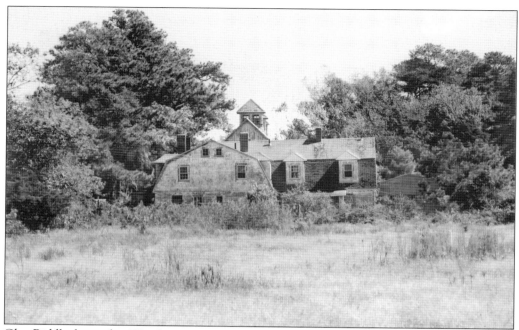

Glen Riddle, located in Worchester County, Maryland, was once home to one of the most famous horses of all time—Man o'War. Glen Doyle Riddle purchased the 17,000-acre farm in 1915. The main house, which was destroyed by fire in 1969, was a 13-room, white Colonial frame house built in 1869. It featured eight bedrooms with seven baths. The rooms were furnished with exquisite antiques, rare books, paintings, and ship models. There was a six-car garage and a dormitory with 10 rooms that provided living quarters for 25 jockeys. (Courtesy Barri B. Reightler.)

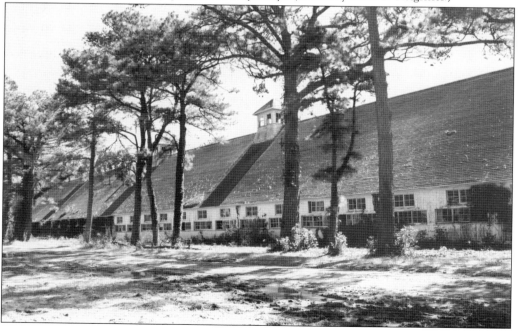

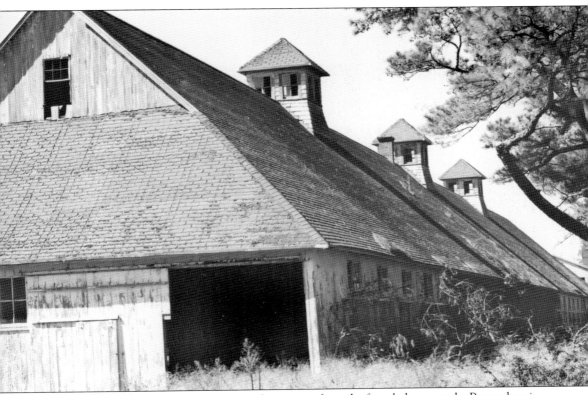

The stables could accommodate 60 horses. A lane across from the farm led to a nearby Pennsylvania Railroad siding where Riddle's Thoroughbreds traveled aboard specially outfitted horse cars to and from Glen Riddle. Riddle acquired the famous Man o'War in 1918 from the Saratoga Yearling Sale for $5,000. Man o'War went on to sire the legendary War Admiral, immortalized in the recent film *Seabiscuit*. Today, all that is left of the beautiful yellow buildings with green roofing is the original training barn seen here. The farm has been purchased by a developer. (Courtesy Barrie B. Reightler.)

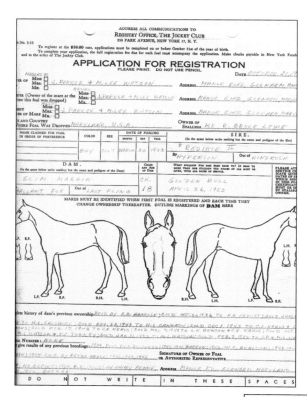

Owners must fill out a form to register their Thoroughbreds with the Jockey Club in New York. There are a number of restrictions on what names may be used, which sometimes cause owners vexation in an attempt to come up with something new that sounds reasonably noble or clever. Today, these horses are also tattooed under their upper lip with an identifying mark. This number is checked immediately prior to each race, to ensure there are no unsavory last-minute exchanges. (Courtesy Parker and Lee Watson.)

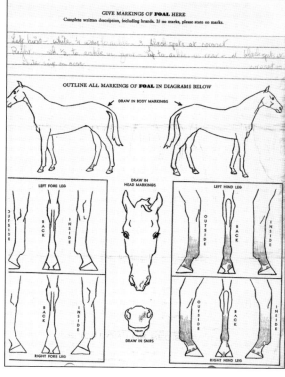

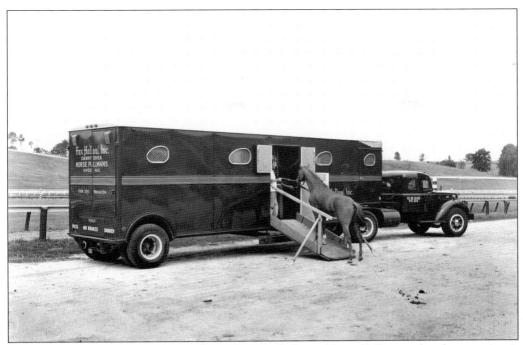

Equine superstars only travel first class. This van bills itself as a Pullman, thereby equating it with commodious transportation and fine service. The vans of today can be as large as a tractor trailer and usually feature closed-circuit television, as well as air conditioning, specially cushioned floors and walls, food, and water. Some farms own their own coaches or vans, while others opt to hire them—a horse taxi, one might say. The cost of transportation has grown exponentially since the bill listed here. (Courtesy Betty Shea Miller and Parker and Lee Watson.)

Valley 3-1639
Valley 5-3206

WILLIAM E. HARR
Horse Transportation
LUTHERVILLE, MARYLAND

This is your Invoice

Date September 2 19 53

Shipper Mr. J. P. Watson Manor Road Glen Arm, Maryland Consignee Same	From Glen Arm, Maryland	Charges Based On
	To Timonium, Maryland	10-20 Miles

Number	Description	Freight Charges
2	mare & foal	15.00

This invoice must be paid within seven (7) days from receipt in accordance with Inter-state Commerce Commission Regulations	Transportation 3% Tax	.45
	Total	15.45

81

Windfields' Stallions . . .

known by the company they keep!

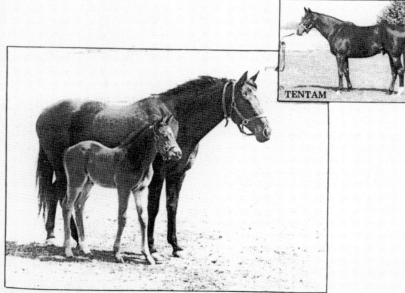

TENTAM

Mr. and Mrs. Peter F. Green's CONSTANT NYMPH, shown here with her March 3 *Le Fabuleux colt, has been bred to Tentam this season and is now in foal. She is the dam of EQUANIMITY, winner this year of the $100,000-added Fantasy Stakes (gr. I). Tentam's son SHELTER HALF is a three-time stakes winner already in 1978.

E. P. Taylor, the founder of Windfields, was a man of many interests always eager for a challenge, and Thoroughbred racing was one of them. By the time he was 30, he had owned, operated, and sold a bus company as well as a taxi company. He had worked his way from bond salesman to a partner in the brokerage firm. He is credited with inventing the modern-day toaster. He also incorporated the Brewing Corporation of Ontario. (Courtesy Maryland Horse Breeders Association.)

E. P. Taylor and his wife, Winifred, started their Thoroughbred operation, known as Windfields, in Oshawa, Canada. In 1964, the same year that Northern Dancer won the Preakness, the Taylors moved their operation to Chesapeake City, Maryland. (Courtesy Maryland Horse Breeders Association.)

Windfields was in operation in Chesapeake City, Maryland, for 24 years and stood many important stallions. (Courtesy Maryland Horse Breeders Association.)

Mr. Taylor was able to combine his love of horses with a sense of entrepreneurship. It was from his endeavor as an owner of a brewery that he received the bulk of his wealth. He combined his love of horse racing with a shrewd marketing ploy. Since he was legally prohibited from advertising beer, he compromised by naming one of his horses Cosgrave after one of his breweries. He could then hang posters of the horse bearing the name Cosgrave in any tavern he pleased. (Courtesy Maryland Horse Breeders Association.)

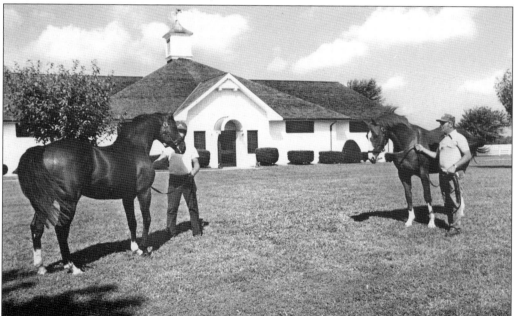

Mrs. Allaire DuPont was a very good friend of the Taylors, and the Taylors fell in love with Maryland on a visit to Mrs. DuPont. They purchased a 2,700-acre piece of land next to Mrs. DuPont's Woodstock Farm and named it Windfields. (Courtesy Maryland Horse Breeders Association.)

A service to Northern Dancer sold prior to the 1986 breeding season was $800,000. Northern Dancer was in great demand as a sire, and many of his offspring have become great race horses. The top three Maryland stallions of 1985 all stood at Windfields. Unfortunately, due to an uncertain economic climate, Windfields closed its operations on August 31, 1988. (Courtesy Maryland Horse Breeders Association.)

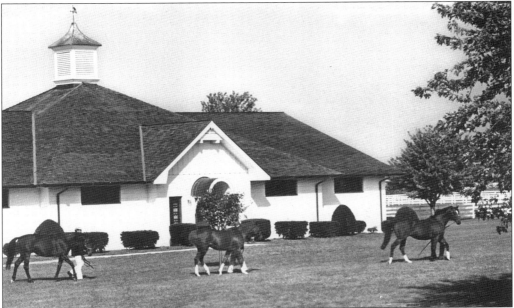

Windfields held many exceptional studs, such as Val de L'Orne, winner of three French Derbies; the Minstrel Champion at three Epsom Irish Sweeps Derbies; and of course, Northern Dancer. Northern Dancer is the sire of a dynasty unparalleled in modern Thoroughbred racing. (Courtesy Maryland Horse Breeders Association.)

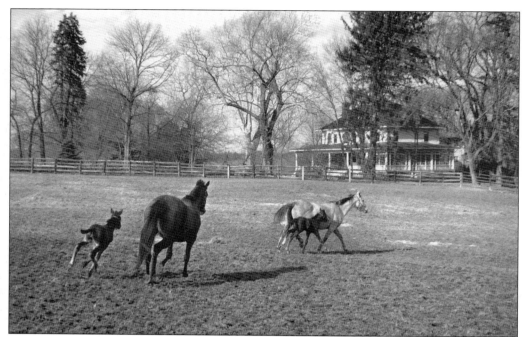

The tradition of excellence continues at Country Life Farm in the capable hands of brothers Josh and Joe Pons. Josh was the two-time president of the MHBA. Joe brought stallions such as Saggy and Correspondent to stand at Country Life. Country Life Farm continues to thrive today as a family-owned breeding operation and nursery. (Courtesy the Pons family.)

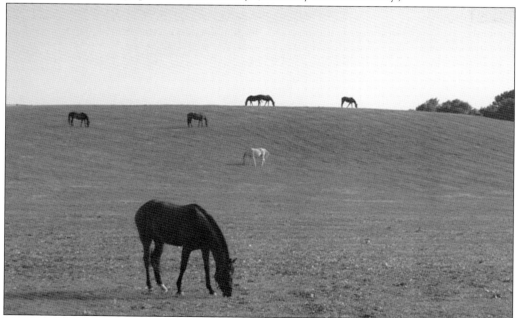

Many exceptional stallions and broodmares have graced the fields of Country Life, including Discovery, who raced for Country Life Farms as a two-year-old in 1933. The foundation mare Raise You, dam of Raise a Native, was bred by Country Life in 1946. (Courtesy the Pons family.)

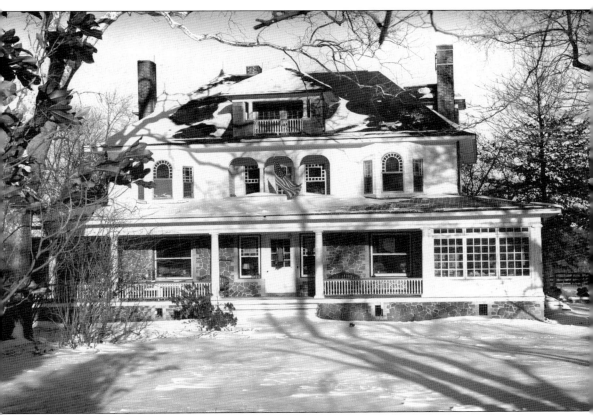

Established in 1933, Country Life Farm, located in Bel Air, Maryland, is the oldest Thoroughbred farm in Maryland. It was founded by Adolphe Pons, who was the valued adviser to August Belmont II. Mr. Pons handled the sale of Man o'War at the Saratoga Yearling Sale. (Courtesy the Pons family.)

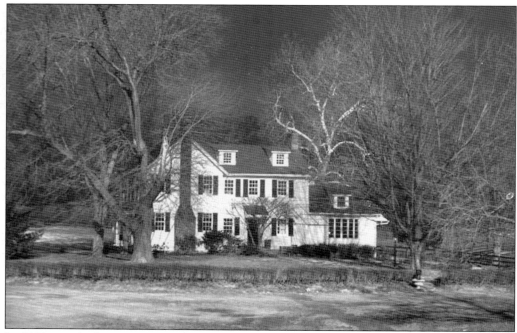

In 2001, nearby historic Merryland Farms was added to Country Life's holdings, renamed as Country Life Nursery. (Courtesy the Pons family.)

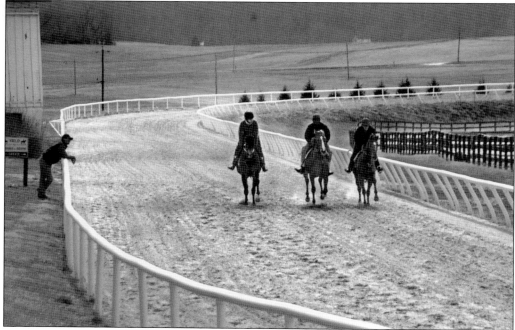

Country Life Nursery completed renovations in 2004 on a new, five-eighths-mile track and offers training as well as lay-ups. (Courtesy the Pons family.)

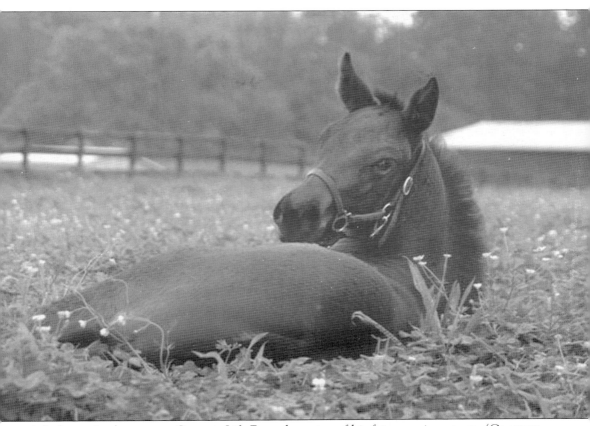

A foal rests in the grass at Country Life Farm dreaming of his future racing career. (Courtesy the Pons family.)

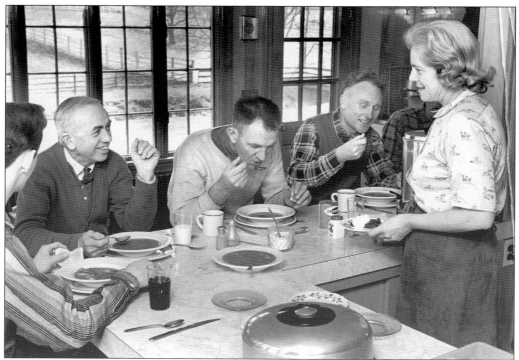

The track kitchen at Merryland was a busy place where staff could buy hearty meals for a nominal sum. On the cook's day off, Mrs. Shea, the owner, stepped right in to help. The kitchen today looks much the same—with the addition of the racing channels on the television. (Courtesy Betty Shea Miller and Ellen B. Pons.)

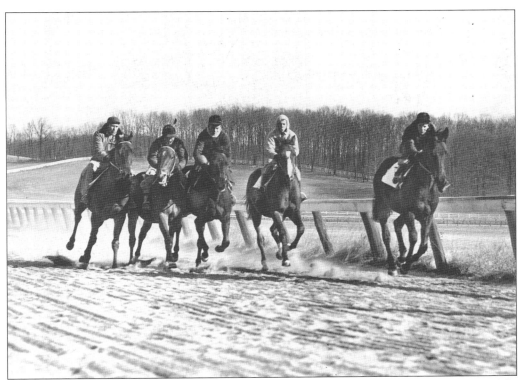

An ex-Woodward string of yearlings works out on the training track at Merryland. In the middle is the future winner Nashville. (Courtesy Betty Shea Miller.)

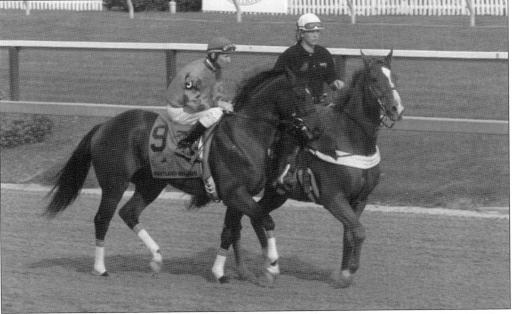

Merryland Missy is one of the current stars of Country Life Farm. She won the Maryland Million Distaff in 2004. (Courtesy Ellen B. Pons.)

Beautiful Halcyon Farm on Greenspring Avenue has been raising winners for many decades. Its horses have won many steeplechase and timber races as well as flat. (Courtesy authors' collection.)

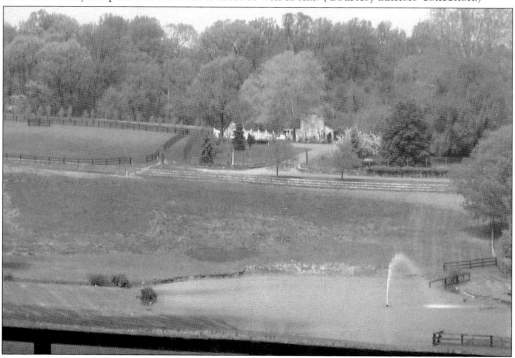

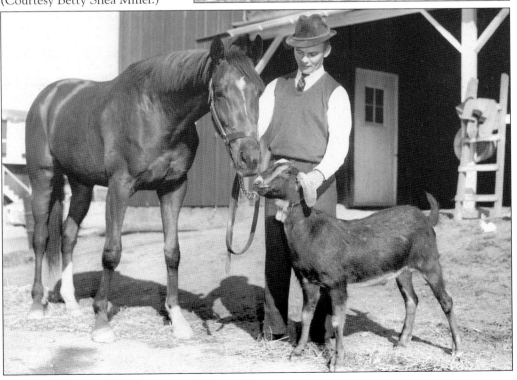

Many racehorses have a stable companion that travels with them. They frequently develop a deep bond of affection, and the pal is usually useful in keeping the horse calm (or at least calmer). Stable pals are usually a dog, goat, pony, donkey, or even a chicken. The goat pictured here smoking a cigarette looks like it would have a rather unsavory effect on its charge. (Courtesy Betty Shea Miller.)

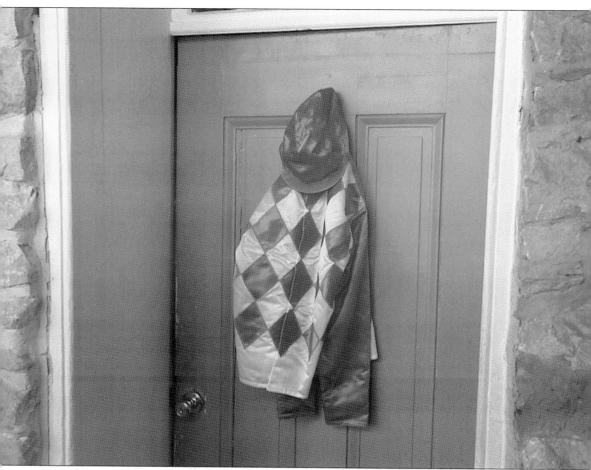

Hanging on a door are a jockey's "silks." These brightly colored uniforms were first made of silk but are now made of nylon. They are used to identify the colors of the farm or owner that a particular horse races for. A jockey may have to change his silks as many times as he has races in a day, since each farm has its own distinctive color and pattern, registered with the Jockey Club. (Courtesy authors' collection.)

Three

LEGENDS AND LONG SHOTS

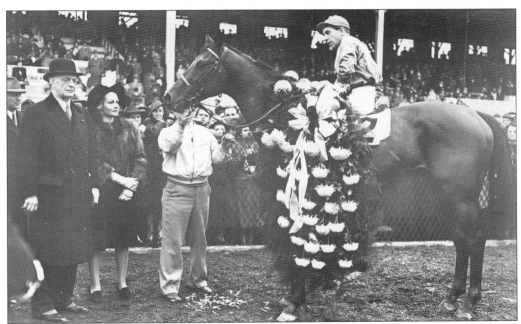

"Challedon was truly an ambassador for Maryland representing every aspect of the state's Thoroughbred industry. He was conceived, foaled and raised on Free State soil," stated Cindy Deubler of the Maryland Horse Breeders Association. He was the first Maryland-bred horse to be named Horse of the Year. Challedon was foaled in 1936 by Laura Gal at Brancastle Farm. Brancastle Farm and Challedon were owned by two retired businessmen, William S. Brann and Robert S. Castle. The horse was such a celebrity that he was eulogized in a song written in his honor that was sung to the tune of "Maryland, My Maryland." (Courtesy Maryland Horse Breeders Association.)

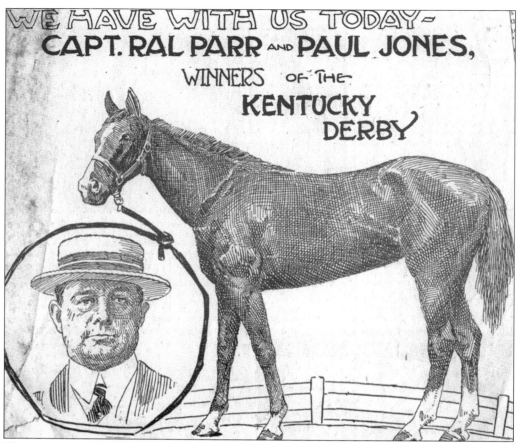

The renowned Paul Jones was owned by Ral Parr and won both the 1920 Kentucky Derby and the Suburban. Paul Jones and Parr were eulogized all over and were very well known both nationally and internationally, despite the lack of 24-hour cable television news. (Courtesy authors' collection.)

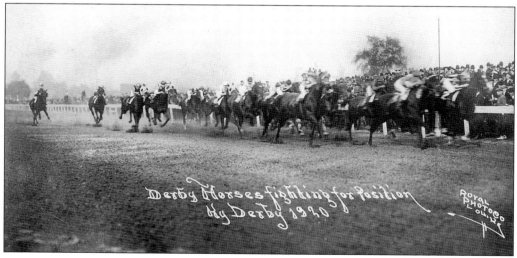

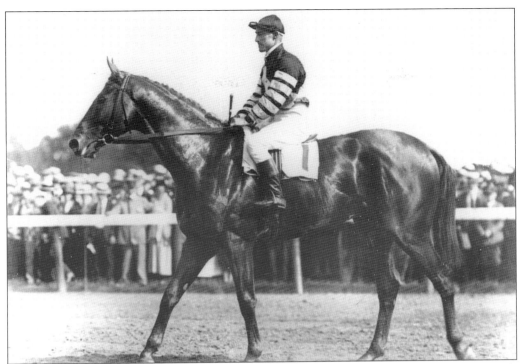

Some say Man o'War was the greatest racehorse of all time. He was a big horse, standing 16.5 hands high with a stride of 25 to 27 feet in length. He won 20 of his 21 races, set five American and world track records and earned $249,465. Although his racing career was short—only two years during 1919 and 1920—his fame is legendary. (Courtesy Maryland Horse Breeders Association.)

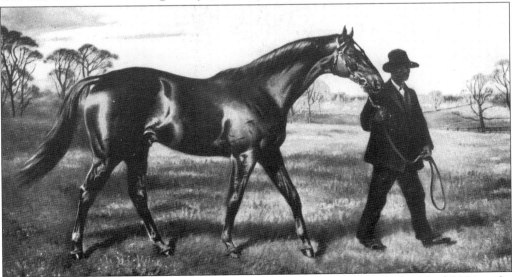

Samuel D. Riddle was the owner of the famous Man o'War. Riddle bought him for $5,000 at the Saratoga Yearling Sale in 1918. Man o'War not only had an exceptional racing career, but he also produced legendary offspring such as War Relic, American Flag, and War Admiral. (Courtesy Maryland Horse Breeders Association.)

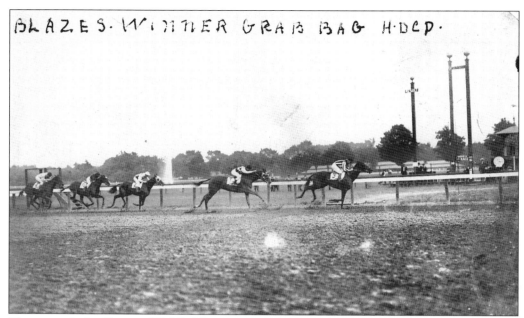

Blazes was the lead horse of Col. Ral Parr's second string. In 1920, he won the Grab Bag Handicap, as well as virtually all the other races he entered. Colonel Parr's red, black, and white striped silks, with black cap, were seen in winner's circle photos perhaps far more often than his competitors would have liked. (Courtesy authors' collection.)

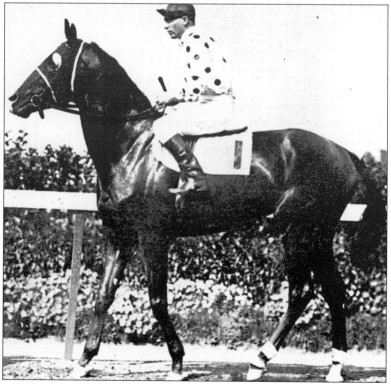

Gallant Fox, owned by the Woodward family of Belair Stud, was one of the greatest racehorses and successful sires of the 20th century. He won the Triple Crown, as did Omaha, making them the only father-son team to achieve that remarkable distinction. (Courtesy Maryland Jockey Club.)

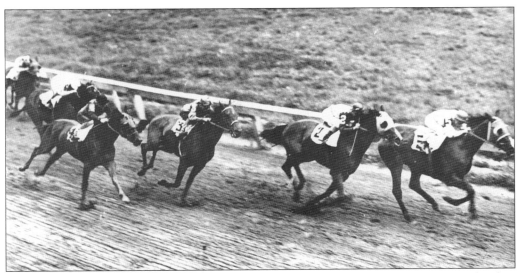

In the 1939 Preakness, Challedon defeated Gilded Knight and Johnstown to win. It was his first win as a three-year-old. He was inducted into the Hall of Fame in 1977. (Courtesy Maryland Horse Breeders Association.)

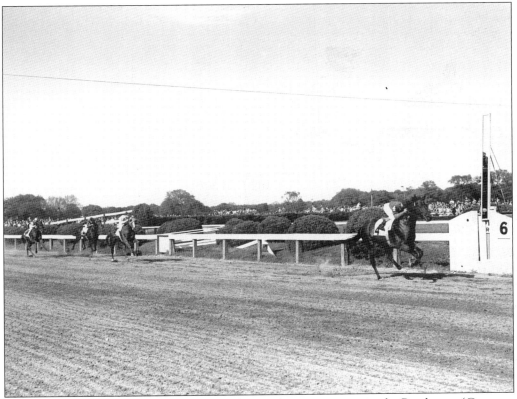

The great Citation roars down to the finish line without opposition in the Preakness. (Courtesy Maryland Horse Breeders Association.)

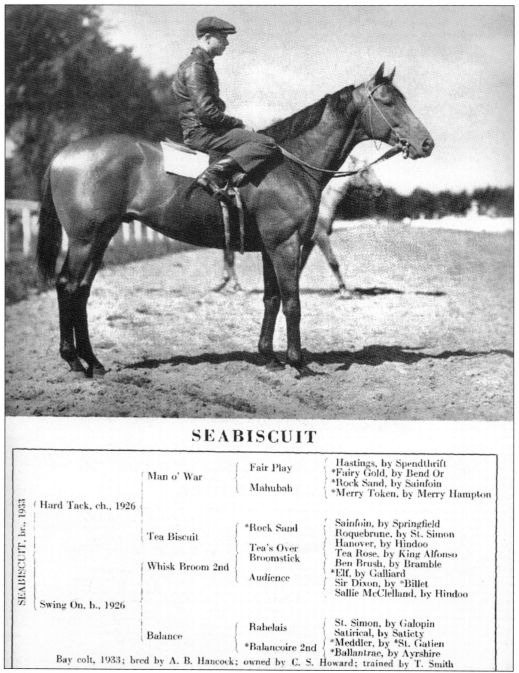

SEABISCUIT

SEABISCUIT, br., 1933			
Hard Tack, ch., 1926	Man o' War	Fair Play	Hastings, by Spendthrift
			*Fairy Gold, by Bend Or
		Mahubah	*Rock Sand, by Sainfoin
			*Merry Token, by Merry Hampton
	Tea Biscuit	*Rock Sand	Sainfoin, by Springfield
			Roquebrune, by St. Simon
		Tea's Over	Hanover, by Hindoo
			Tea Rose, by King Alfonso
Swing On, b., 1926	Whisk Broom 2nd	Broomstick	Ben Brush, by Bramble
			*Elf, by Galliard
		Audience	Sir Dixon, by *Billet
			Sallie McClelland, by Hindoo
	Balance	Rabelais	St. Simon, by Galopin
			Satirical, by Satiety
		*Balancoire 2nd	*Meddler, by *St. Gatien
			*Ballantrae, by Ayrshire

Bay colt, 1933; bred by A. B. Hancock; owned by C. S. Howard; trained by T. Smith

Seabiscuit (above) and War Admiral (opposite page) were worthy opponents and closely related. The paths that each took to arrive at their match race were markedly different and helped to fuel the tremendous fascination felt by the public toward the two horses. (Both courtesy Maryland Jockey Club.)

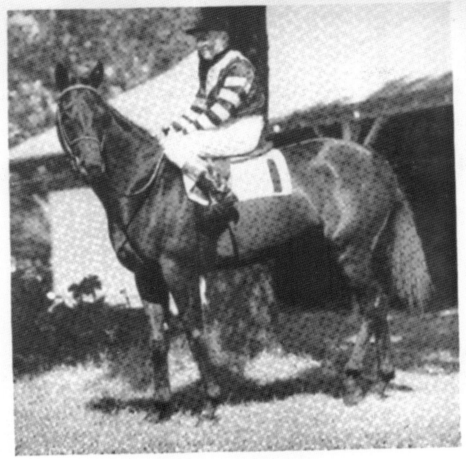

WAR ADMIRAL

Man o' War, ch., 1917	Fair Play	Hastings	Spendthrift, by Australian *Cinderella, by Tomahawk or Blue Ruin
		*Fairy Gold	Bend Or, by Doncaster Dame Masham, by Galliard
	Mahubah	*Rock Sand	Sainfoin, by Springfield Roquebrune, by St. Simon
		*Merry Token	Merry Hampton, by Hampton Mizpah, by Macgregor
Brushup, b., 1929	Sweep	Ben Brush	Bramble, by *Bonnie Scotland Roseville, by Reform
		Pink Domino	Domino, by Himyar *Belle Rose, by Beaudesert
	Annette K.	Harry of Hereford	John o' Gaunt, by Isinglass Canterbury Pilgrim, by Tristan
		*Bathing Girl	Spearmint, by Carbine Summer Girl, by Sundridge

WAR ADMIRAL, br., 1931

Brown colt, 1934; bred by Samuel D. Riddle; owned by Glen Riddle Farm; trained by George Conway

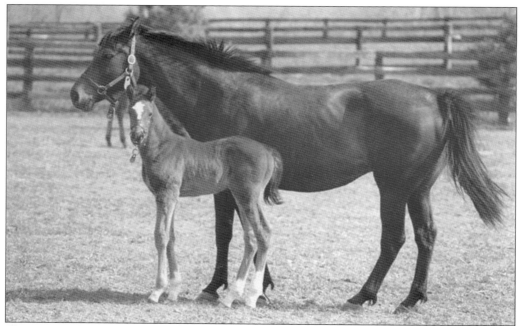

Champions all start somewhere, and here is the superstar Cigar as a foal at Country Life Farm. With his glory years still ahead of him, the care and training lavished on him early on helped mold him for later success. (Courtesy Ellen B. Pons.)

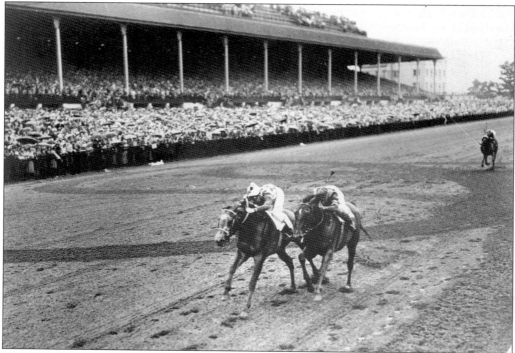

Maryland's own Native Dancer roars to a win at Belmont. (Courtesy Maryland Horse Breeders Association.)

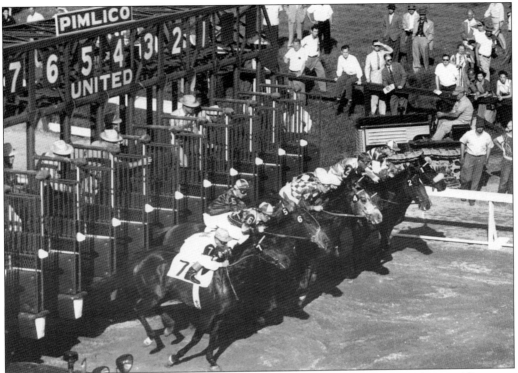

Native Dancer flies out of the gate in front of his home crowd at the Preakness. (Courtesy Maryland Horse Breeders Association.)

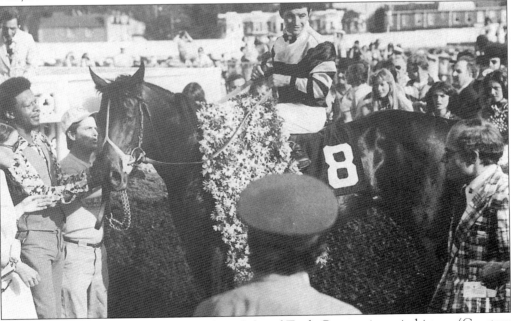

Maryland-trained Seattle Slew is the only undefeated Triple Crown winner in history. (Courtesy Maryland Jockey Club.)

Citidancer is now enjoying a second career at stud at Country Life Farm, and his progeny have had successful careers of their own. He sired three Maryland Million winners who won on the same day (which must be a record) and numerous stakes winners. (Courtesy Ellen B. Pons.)

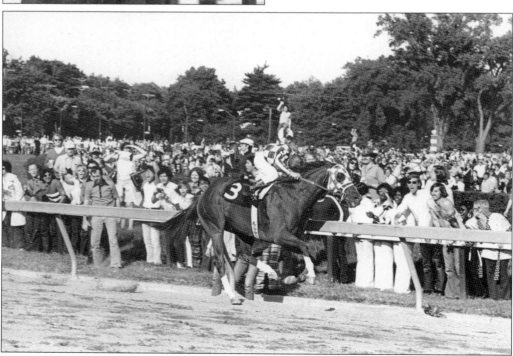

Believed by many to be the horse of the century, the unsurpassed Secretariat won the Preakness as part of his Triple Crown sweep. (Courtesy Maryland Jockey Club.)

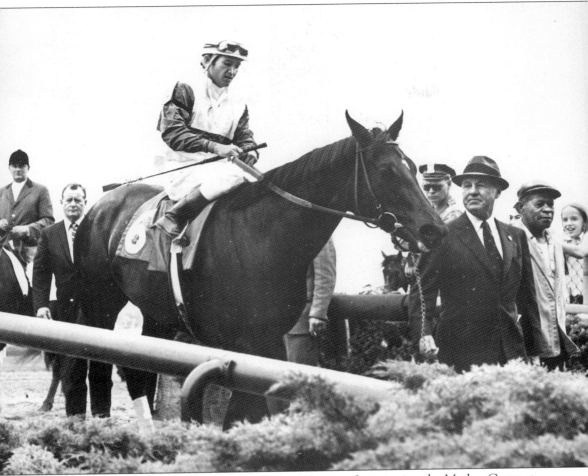

Beautiful Ruffian is shown here with jockey Jacinto Vasquez after winning the Mother Goose at Aqueduct. She is being led by Maryland owner Stuart Janney. (Courtesy Bob Coglianese, New York Racing Association.)

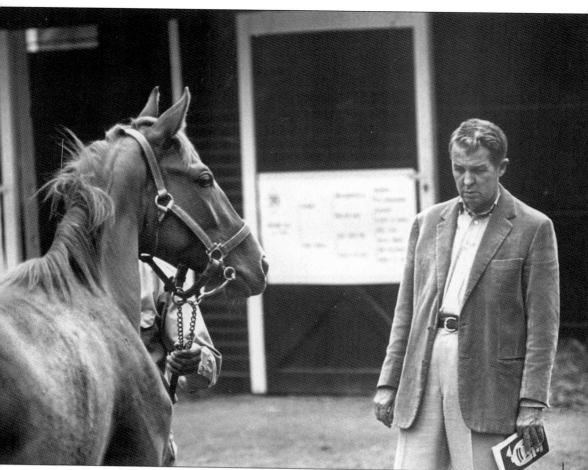

Legendary Maryland horseman Alfred G. Vanderbilt may have been given Sagamore, but he built his own Thoroughbred empire. He started by purchasing Discovery as a two-year-old for $25,000. Discovery, standing at Sagamore, became the foundation of Vanderbilt's breeding operation. Discovery's daughter was Geisha, dam of Native Dancer. Ralph Kercheval was Mr. Vanderbilt's manager at Sagamore. (Courtesy Peter Winants.)

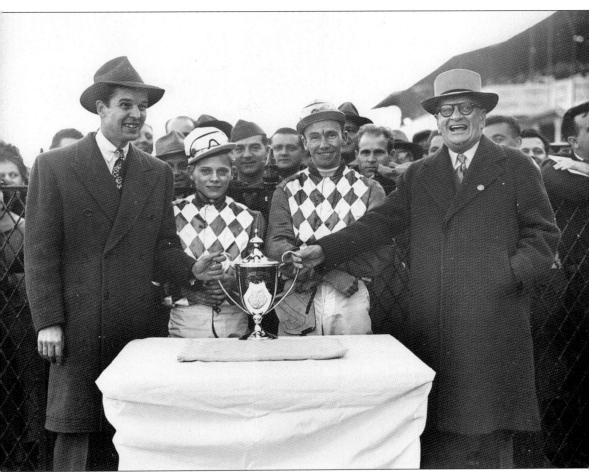

Winning owner A. G. Vanderbilt (left) poses with, from left to right, jockeys W. J. Passruare and N. Conibest and Matt Daiger in 1948. (Courtesy Maryland Horse Breeders Association.)

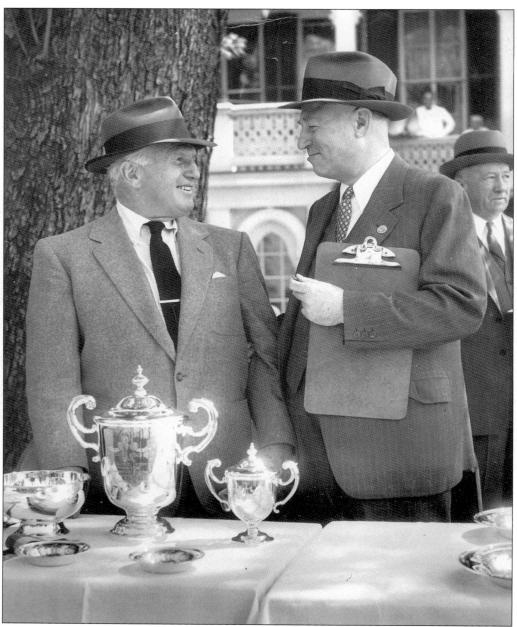

The legendary Danny Shea (left), a horseman's horseman if ever there was one, is shown here sharing a light moment with a fellow judge. Danny wore many hats, as owner, breeder, rider, trainer, and judge. He was respected for his talent and beloved by many for his sense of humor. (Courtesy Betty Shea Miller.)

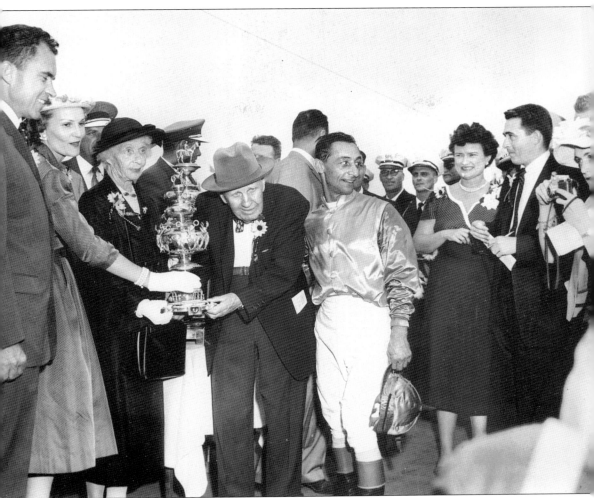

This 1957 photograph of legendary trainer Sunny Jim Fitzsimmons accepting the Preakness Trophy captures many familiar faces. From left to right are Vice Pres. and Mrs. Richard Nixon, Mrs. Henry Carnegie Phipps, Sunny Jim Fitzsimmons, jockey Eddie Arcaro, Molly Collum, Joe Hickey, and Kathleen Fitzsimmons. (Courtesy Maryland Jockey Club.)

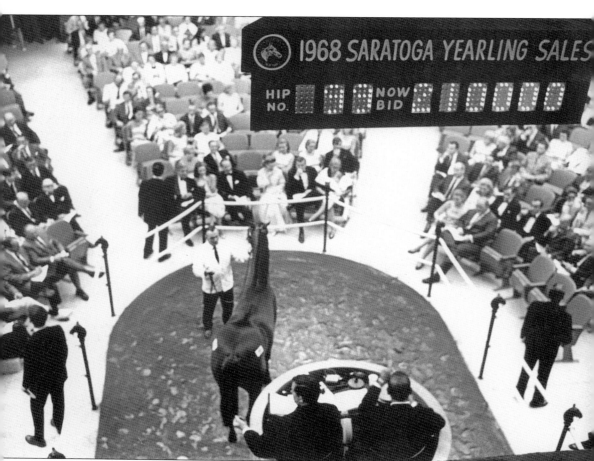

Thoroughbred auctions held by Fasig-Tipton have a panache all their own, befitting the rarefied world they inhabit. Often black-tie affairs, they transform a mundane event into an occasion. Perhaps that is the best way to handle things when millions of dollars are on the block. Fasig-Tipton was founded by William Fasig and Edward Tipton in 1898. Now headquartered in Kentucky, their mid-Atlantic office is located in Timonium, Maryland. In addition, there are other branches, including Japan. Their famous yearling sales in Saratoga have been an annual event for almost 100 years. (Courtesy Michael Finney.)

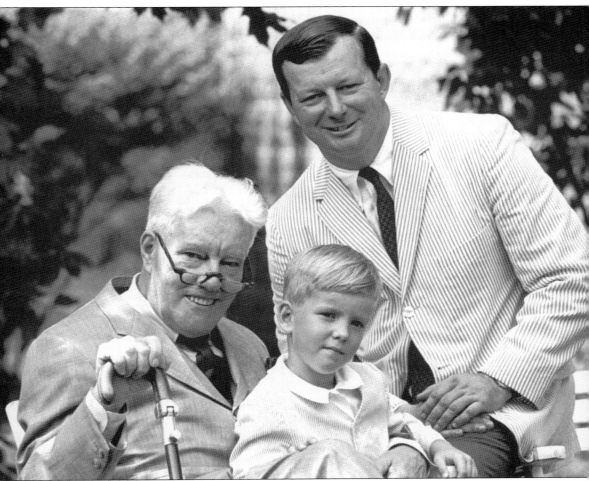

Three generations of the Finney family are shown here from left to right: Humphrey, John (standing), and Michael. The elder Finneys piloted Fasig-Tipton with honesty and skill for many years. Known for their integrity, kindness, and humor, their skill wielding the gavel at auctions or casting a keen eye of appraisal over the nearest equine asset have ensured them a place in the affections of the sporting world. (Courtesy Michael Finney.)

Ral and Sonia Parr circumnavigated the globe five times, in addition to sundry trips to various continents to watch the racing and perhaps buy a horse or two. Their horses raced up and down the East Coast, as well as Cuba, Florida, Louisiana, and California. Sonia was well known for her beauty and sense of style. In addition to her love of horses, she raised champion Pekinese. (Courtesy authors' collection.)

Joe (left) and August Pons represent two of the four generations that have been involved in the operation of Country Life Farm. (Courtesy Ellen B. Pons.)

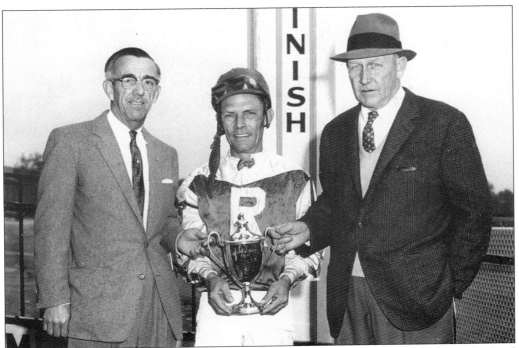

Jockey Bobby Beurd and trainer Howard Jacobson (left) accept the Walden Trophy from Maryland horseman Henry S. Clark. (Courtesy Maryland Horse Breeders Association.)

Bonita Farm is also a family endeavor. Pictured here is the patriarch Bill Boniface, who is a noted owner, breeder, and trainer. The famed Kentucky Derby winner Go for Gin is at stud at Bonita. (Courtesy the Boniface family.)

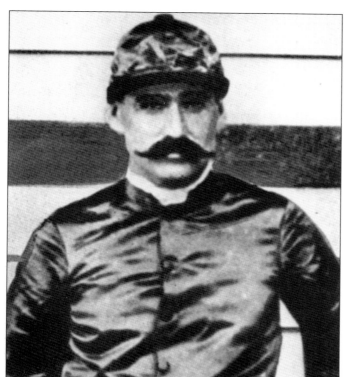

Dapper Jockey Hall of Fame member James McLaughlin was a star of the late 19th century. Note the fashionable mustache. (Courtesy Maryland Jockey Club.)

Several legendary jockeys joke it up. Pictured here from left to right are an unidentified top Maryland jockey, Steve Cauthen, and Bill Shoemaker. (Courtesy Maryland Jockey Club.)

There were many great jockeys in the early years of the 20th century, and Carroll Shilling was one of them. (Courtesy Maryland Jockey Club.)

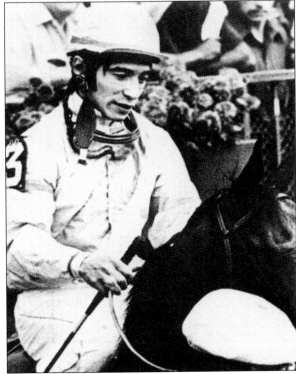

No roster of top jockeys would be complete without the great Lafitte Pincay Jr., who rode many winners and was the top money earner for much of the 1970s. (Courtesy Maryland Jockey Club.)

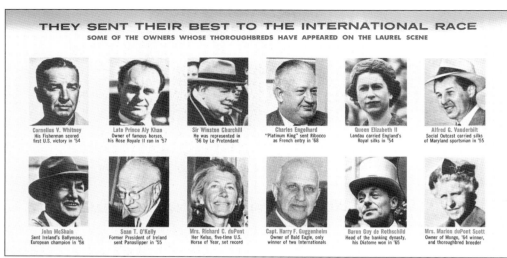

THEY SENT THEIR BEST TO THE INTERNATIONAL RACE
SOME OF THE OWNERS WHOSE THOROUGHBREDS HAVE APPEARED ON THE LAUREL SCENE

Cornelius V. Whitney
His Fisherman scored first U.S. victory in '54

Late Prince Aly Khan
Owner of famous horses, his Rose Royale II ran in '57

Sir Winston Churchill
He was represented in '56 by Le Pretendant

Charles Engelhard
"Platinum King" sent Ribocco as French entry in '68

Queen Elizabeth II
Landau carried England's Royal silks in '54

Alfred G. Vanderbilt
Social Outcast carried silks of Maryland sportsman in '55

John McShain
Sent Ireland's Ballymoss, European champion in '58

Sean T. O'Kelly
Former President of Ireland sent Panaslipper in '55

Mrs. Richard C. duPont
Her Kelso, five-time U.S. Horse of Year, set record

Capt. Harry F. Guggenheim
Owner of Bald Eagle, only winner of two Internationals

Baron Guy de Rothschild
Head of the banking dynasty, his Diatome won in '65

Mrs. Marion duPont Scott
Owner of Mongo, '64 winner, and thoroughbred breeder

Particularly since it was the first truly international race, the Washington, D.C. International at Laurel attracted owners with global name recognition, such as Queen Elizabeth and Aly Khan. Sadly, neither a crown nor blue blood grants one automatic access to the winner's circle. (Courtesy Maryland Jockey Club and Enoch Pratt Free Library.)

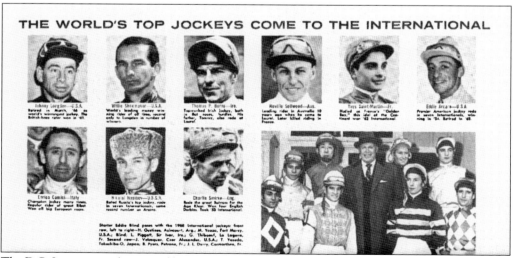

THE WORLD'S TOP JOCKEYS COME TO THE INTERNATIONAL

The D.C. International attracted horses—and jockeys—from all over the world, including England, France, and even Russia. (Courtesy Maryland Jockey Club and Enoch Pratt Free Library.)

In honor of gallant Wilwyn from England, hero of the 1952 International, the first one, Laurel stages a grass race in the spring known as the Wilwyn Handicap. Here is General Omar N. Bradley, World War II hero, center, with Sidney Smith, trainer of the winning Mozart, and jockey Bobby Corle, holding the Wilwyn Trophy at the 1961 Spring meet.

Seen at the International Ball

Described as one of the most brilliant social events of the year, the fabulous International Ball is held every November on the eve of the Washington, D. C. International race. It is one of the biggest fund-raising events of its type in the country, with the Children's Convalescent Hospital in Washington deriving the benefits. Diplomats, government officials, nationally-known socialites, as well as horse owners and horse lovers gather in at the Sheraton-Park Hotel grand ballroom in Washington to salute countries represented in the International race.

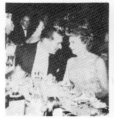

Wiley T. Buchanan, former U.S. Chief of Protocol and Mrs. Elizabeth (Arden) Graham exchange information on "best bets."

Mrs. Hugh Auchincloss, mother of Jacqueline Kennedy, with Edward Foley, special assistant to President Kennedy.

Joan Fontaine and Douglas Fairbanks, Jr., internationally known film stars, discuss the International Race at the Ball.

Seen at the Racing Classic...

November 11 is the big day in racing, for it's the day of the famous Washington, D. C. International. All walks of life feel this sporting urge to head for Maryland's largest and most modern race course, and they come from Europe, the Pacific, South America, California, Canada, Mexico, and even from Russia. Names prominent in diplomatic, governmental, theatrical, and social circles have signed the Laurel guest book. Indeed, there are no boundaries to Laurel International enthusiasm and patronage.

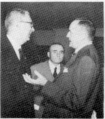

Former Ambassador Manlio Brosio of Italy with Commendatore Mantovani, owner of Rio Marin, Italian entry in the race.

Dr. Thomas J. Kiernan, Irish ambassador, and Mrs. Kiernan favor the Irish entry "Farney Fox" in the 1960 race.

Lady Caccia, wife of the former British ambassador, decides between the British entries, Prolific and Apostle 2nd.

This brochure has been prepared and compiled by Bill Jaeger and Emanuel

The International Ball, which preceded the race, was a glittering white-tie affair that attracted socialites, diplomats, and devotees of the sport from around the world. (Courtesy Maryland Jockey Club and Enoch Pratt Free Library.)

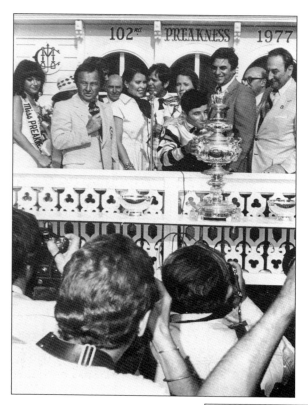

Legendary ABC Television sports commentator Jim McKay has played a key role in promoting Thoroughbred racing in Maryland. He enthuses, "I love Maryland. I love Maryland racing. This is the best place to live." McKay was responsible for founding the popular Maryland Million, modeled on the Breeders Cup. Maryland was the first state to implement its own showcase of its racing talent. (Courtesy Maryland Jockey Club.)

The Maryland Jockey Club is the nation's oldest, having been founded in Annapolis in 1743. Its intricate logo, featured since 1830, is comprised of racing items gently molded into the letters MJC. A bit, whip, spur, and stirrups lend the logo its clever appearance. The Jockey Club has held meetings since Colonial days, with a few years off here and there due to historical intrusions, such as the American Revolution, the French-Indian War, and the Civil War. Among other noted dignitaries, Gen. George Washington, a fine horseman himself, happily attended. (Courtesy Maryland Jockey Club.)

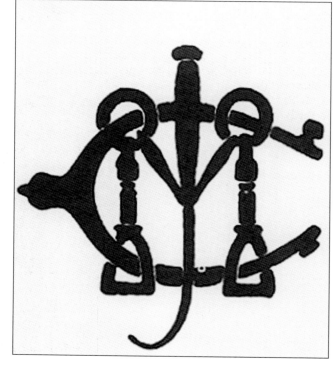

The beautiful horse and the beautiful woman (both wearing fur) share the name Ruth Wallis. Known as "America's No. 1 Singer of Saucy Songs," the chanteuse was acclaimed for her unforgettable standards, such as "It's a Scream When Leverne Does the Rhumba," "Psycho Mambo," "Stay Out of My Pantry," and "Tonight You Sleep in the Bathtub." The horse went on to its own, less saucy, success. (Courtesy Parker and Lee Watson.)

Presenting

RUTH WALLIS

America's No. 1 Singer of Saucy Songs

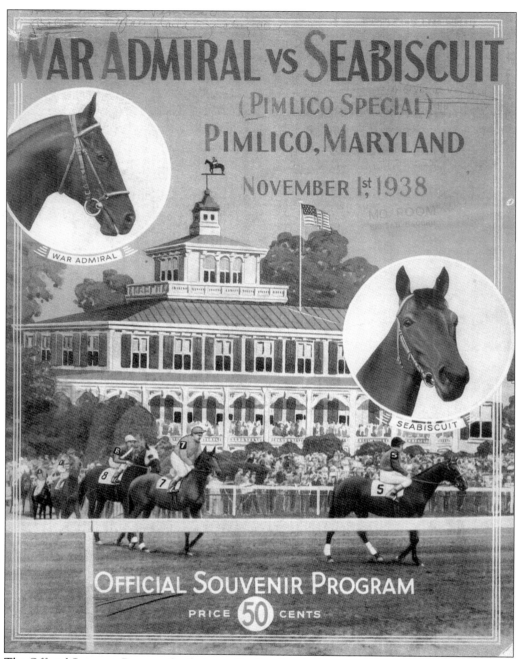

The Official Souvenir Program for the great Pimlico Special between War Admiral and Seabiscuit was a keepsake for many. Filled with the vital statistics and pedigrees of the fleet four-footed stars of the day, it also included a listing of boxholders. The list was a virtual who's who of the leading figures of the national racing scene, such as Riddle, Howard, DuPont, Whitney, Vanderbilt, Janney, Parr, and Payson. (Courtesy Maryland Jockey Club and Enoch Pratt Free Library.)

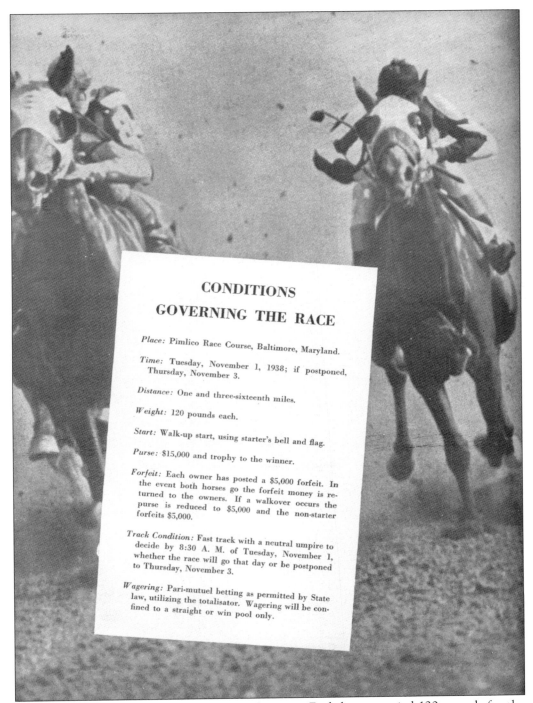

CONDITIONS
GOVERNING THE RACE

Place: Pimlico Race Course, Baltimore, Maryland.

Time: Tuesday, November 1, 1938; if postponed, Thursday, November 3.

Distance: One and three-sixteenth miles.

Weight: 120 pounds each.

Start: Walk-up start, using starter's bell and flag.

Purse: $15,000 and trophy to the winner.

Forfeit: Each owner has posted a $5,000 forfeit. In the event both horses go the forfeit money is returned to the owners. If a walkover occurs the purse is reduced to $5,000 and the non-starter forfeits $5,000.

Track Condition: Fast track with a neutral umpire to decide by 8:30 A. M. of Tuesday, November 1, whether the race will go that day or be postponed to Thursday, November 3.

Wagering: Pari-mutuel betting as permitted by State law, utilizing the totalisator. Wagering will be confined to a straight or win pool only.

There were specific conditions governing this race. Each horse carried 120 pounds for the one-and-three-sixteenths of a mile distance. There was a walk-up start. The victor received not only the spoils but a trophy and $15,000. (Courtesy Maryland Jockey Club and Enoch Pratt Free Library.)

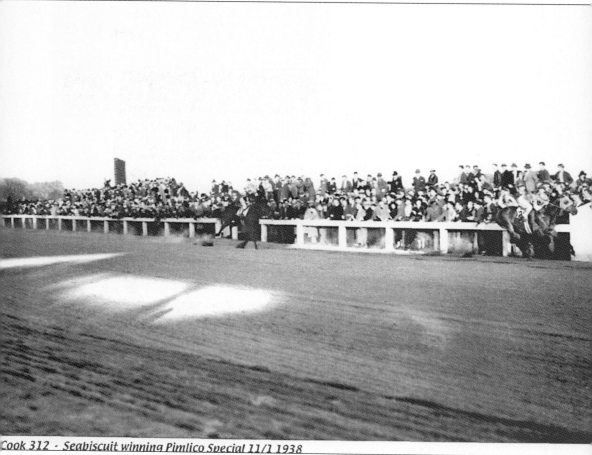

Cook 312 - Seabiscuit winning Pimlico Special 11/1 1938

Seabiscuit races to the finish four lengths ahead of War Admiral in one of the most anticipated and exciting races ever. While War Admiral was the favorite, the feelings of supporters on both sides ran at a fever pitch. A win by four lengths made the race all the more memorable. (Courtesy Keeneland Library.)

There are many Preakness traditions, and pre-, post-, and post-post parties play an integral role. Those who love horse racing or just love a good party will find their niche. From the reserved to the raucous, the town is in full celebratory mode. This Preakness party program from 1941 cautions that "out-of-town guests" must be actual, bona fide out-of-towners—no pretending allowed. It must have been a heck of a party! (Courtesy Enoch Pratt Free Library.)

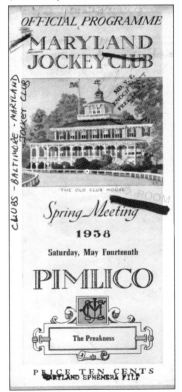

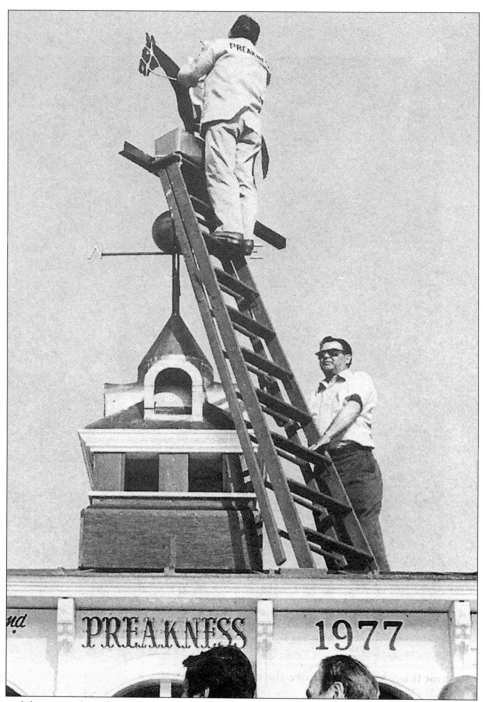

One of the most cherished Preakness traditions is the painting of the colors, which was begun in the early 20th century. An intrepid painter climbs atop the cupola to paint the winning colors on the weather vane's jockey. Those colors will remain until the next Preakness Stakes. (Courtesy Maryland Jockey Club.)

With a great flourish of tight security, the most valuable trophy in American sports is ushered onto the track on Preakness day. Locked up the rest of the year, this 34-inch-high silver trophy weighing approximately 30 pounds has been making its appearance at the race since 1917. The horse at the top of the trophy is the legendary Lexington. Made in 1861 by Tiffany and Company, the Woodlawn Vase is of tremendous value. A half-size replica is given each year to the winning owner. (Courtesy Maryland Jockey Club.)

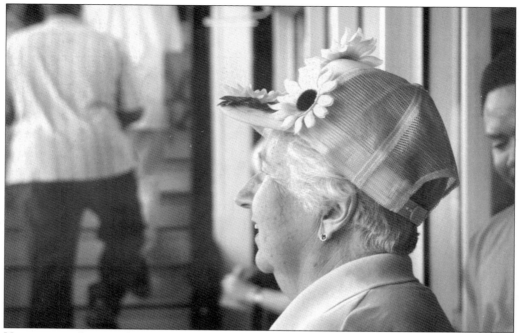

Hats are another Preakness tradition, and all types are on view. The usher above combines another tradition, the black-eyed susan (the winning horse is covered in a blanket of it, despite the fact that the flower is not in bloom in May in Maryland) with a cap, while the fellow below has fashioned a hat from an orange traffic cone. Perhaps his empty cooler played into this sartorial decision. (Courtesy Ellen B. Pons.)

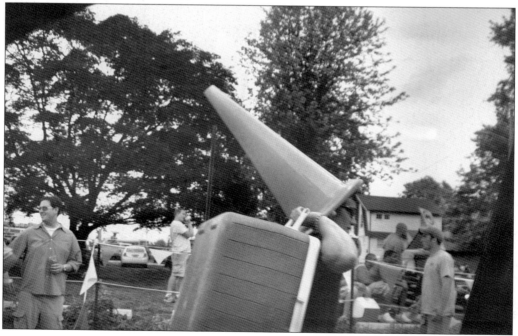

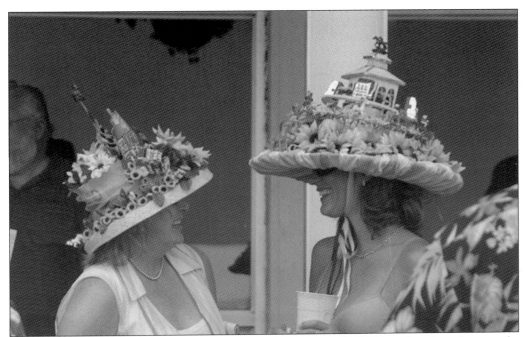

Some people put tremendous creativity into their hat selection. Whether store-bought or homemade, the hat tradition (along with dressing up, singing "Maryland, My Maryland," and rooting for favorites) provide a link with past generations of Marylanders who were proud of their state and proud of their horses. (Courtesy Ellen B. Pons.)

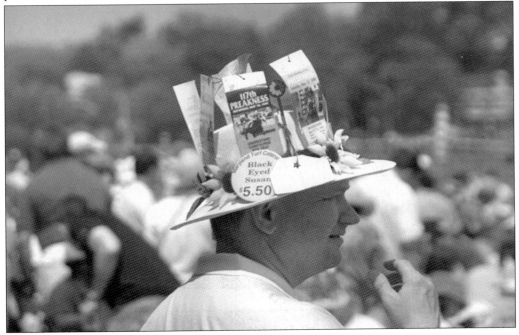

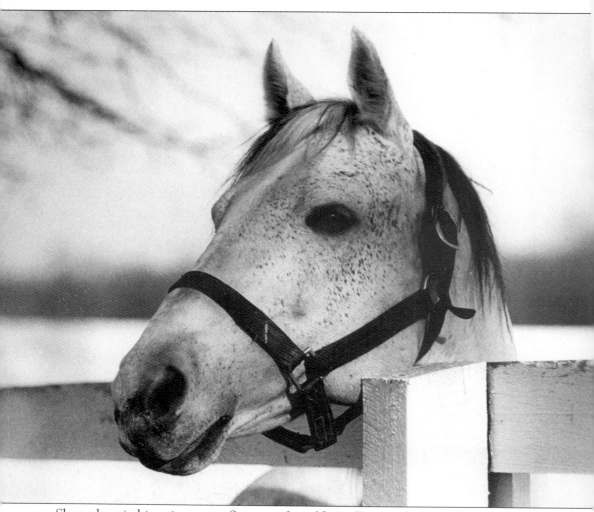

Shown here in his retirement at Sagamore farm, Native Dancer, the "Grey Ghost of Sagamore," is probably one of the most important and influential Maryland-owned and -raised horses in Maryland Thoroughbred racing history. Born in Kentucky in 1950 but raised at Sagamore, Native Dancer was out of Vanderbilt's Maryland-bred mare Geisha. Not only did he have an extraordinary racing career, winning 21 out of 22 starts, but his legacy as a sire is legendary. He entered stud at Sagamore in 1955. He sired 44 stakes winners and created a legacy that includes most of the major Thoroughbred bloodlines. His son, Kauai King, in 1966 became the first Maryland-bred to win the Kentucky Derby. In 1967, Native Dancer died and was buried at Sagamore. Before his death, in that year, his stud fee was $20,000, making him the most expensive privately owned stud in the country. (Courtesy Peter Winants.)